POSTCARD HISTORY SERIES

Montreat

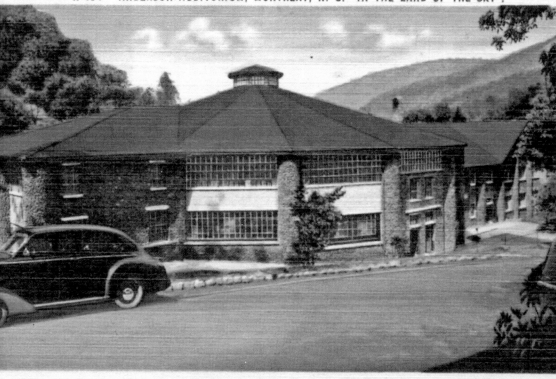

Seating 2,500 and built of rounded stone from Montreat creeks, Anderson Auditorium is the center of the summer season. For over 100 years, Montreat has hosted thousands of individuals each summer at Bible and mission conferences, women's conferences, music and worship conferences, youth conferences, and church retreats. For more than 40 years, church missionaries were trained and commissioned here before departing for service in foreign countries.

ON THE COVER: Assembly Inn and the Lakeside Building are pictured in the 1940s overlooking the activities on Lake Susan, at the heart of Montreat.

ON THE BACK COVER: The stone entrance gate was built in 1923 and marks the entry into a special place called Montreat.

POSTCARD HISTORY SERIES

Montreat

Mary McPhail Standaert and Joseph Standaert

ARCADIA
PUBLISHING

Published by Arcadia Publishing
Charleston, South Carolina

Printed in the United States of America

Library of Congress Control Number: 2008941215

For all general information contact Arcadia Publishing at:
Telephone 843-853-2070
Fax 843-853-0044
E-mail sales@arcadiapublishing.com
For customer service and orders:
Toll-Free 1-888-313-2665

Visit us on the Internet at www.arcadiapublishing.com

*This book is dedicated to the founders of Montreat,
the Presbyterians who purchased Montreat,
and to those who have loved Montreat for over a century.*

CONTENTS

Acknowledgments

We would like to acknowledge those individuals who have recorded Montreat's past through both the written word and through their postcards. Without their text and images, this book would not have been possible. The more than 350 Montreat postcards in the authors' collections are the primary source for the views presented here. Other cards were generously provided through the courtesy of Betsy Hester (BH), Ron Nalley (RN), the Swannanoa Valley Museum (the Johnny Lowry Collection, JLSVM, and its general collection, SVM), and the Presbyterian Heritage Center at Montreat (PHC). Ron Vinson of the Presbyterian Heritage Center, Sue Diehl of Montreat College, and Ron Nalley have provided invaluable research support.

Finally, we must include a special thanks to the individual who started us on this adventure more than 20 years ago by posting a request on the Montreat Post Office bulletin board seeking vintage Montreat postcards and memorabilia. As we were new to Montreat, and the recent history books were yet to be written, we decided that Montreat postcards would be fun to collect and we could learn about Montreat history as well. Recently we have learned the identity of this individual. Thank you, Ron Nalley, now the town administrator of Montreat.

INTRODUCTION

Montreat straddles the eastern continental divide and is framed by the Blue Ridge Mountains on the east and the mountains of the Seven Sisters/Walkertown Ridge on the west. Its elevation ranges from 2,400 feet above sea level at the Montreat Gate to more than 5,360 feet at its highest point on the top of Graybeard Mountain. Native Americans hunted on the land but never built villages. Remote and inaccessible before the coming of the railroad in 1879, the Montreat cove was the last portion of the Swannanoa Valley to be settled. Its original owners were William and Anderson Kelly. In 1888, a group of sheep ranchers, including Pell Sutton, namesake of Sutton Avenue in Black Mountain, purchased the cove from the Kelly family for $1 an acre. Sheep were raised in the mountain highlands and then taken to the coastal markets in South Carolina. The sheep-ranching enterprise was short-lived. The ranchers sold the 4,500-acre property in 1897 to an interdenominational group, primarily from the northeast, for $8 an acre. This group was interested in the formation of a community of rest, recuperation, and Christian study. Two men were instrumental in the formation of Montreat. The lesser known was William Gales, an evangelist in Virginia, who was primarily interested in establishing a Bible conference center. The more well known was Rev. John Chamberlin Collins, a Congregationalist minister from New Haven, Connecticut. He was primarily interested in establishing a health resort for rescue mission and church workers broken in health and spirit.

Montreat was chartered by the State of North Carolina as the Mountain Retreat Association (MRA) on March 2, 1897, and was the first of multiple religious assemblies founded in the area. The initial meeting of the Montreat Managing Committee was held in the LaFayette Avenue Presbyterian Church in New York City on March 25, 1897. Charles Alden Rowland of Athens, Georgia, was the sole southern Presbyterian among the original founders and members of the Montreat Managing Committee. The Mountain Retreat Association purchase was finalized in June 1897. The first "Christian Assembly" was held July 20, 1897, and lasted 10 days. John C. Collins served as president of the Mountain Retreat Association for two years (1897–1899), and William Gales became the general manager in 1899. In 1963, Charles Rowland recalled in his notes on *The Genesis of Montreat* that while "God used John C. Collins to locate and found Montreat, God used William Gales to save, establish, and continue Montreat." The name "Montreat" is a contraction of the more formal term "Mountain Retreat Association" and received its new designation in 1898.

Although the founders had Montreat surveyed by Frederick Odell in 1897 and offered 300 lots to finance the new community, it rapidly fell into financial peril. John S. Huyler, a Methodist and a resident of New York, assumed Montreat's debts and became the owner and second president of Montreat. A wealthy philanthropist, he made his fortune in the candy business, creating a new "molasses-style candy" while working in his father's business and establishing a chain of candy and confectionery shops. He took "Jacob's Pledge" (Genesis 28:22) promising to give 10 percent of his earnings to the Lord. Montreat was the fortunate recipient of the philanthropy of John Huyler, one of the 15 incorporating founders. During his ownership, he searched for a new buyer who would continue with the initial goals of the association. The Montreat property was offered to Willis D. Weatherford for the founding of a home for the YMCA around 1904. The offer was declined as Weatherford felt that Montreat would provide too many distractions to the young men coming for study and reflection since 30 homes had already been built in the community.

At about this same time, members of the North Carolina Presbyterian churches, under the leadership of Rev. James Robert Howerton, pastor of the First Presbyterian Church of

Charlotte, North Carolina, became interested in the acquisition of the Montreat property to serve as a meeting place and religious conference center. In 1905, Huyler made the property available for $50,000, with a one-year option to buy. The Synod of North Carolina endorsed, but did not fund, this purchase in the fall of 1905. In January 1906, at a meeting in Charlotte, North Carolina, plans were made to finance the purchase by offering shares of stock to private individuals at $100 each with $25,000 being paid to Huyler and $25,000 reserved for capital improvements. The property was purchased in the fall of 1906. The purchase was endorsed by the 1907 meeting of the General Assembly in Birmingham, Alabama, and Montreat began its long association with and service to the Presbyterian Church.

Rev. James Howerton became the third president of Montreat. Like Rev. John Collins, his association with Montreat, while pivotal, was brief. Montreat's financial difficulties continued under the Howerton administration, and 600 acres were sold to the Baptists for the Ridgecrest Assembly Grounds. Reverend Howerton left after a year, accepting a position at Washington and Lee University in Lexington, Virginia.

In 1909, Judge James D. Murphy of Asheville, North Carolina, became the fourth president. The Murphy administration was also brief, spanning only two years, 1909 to 1911. In 1910, John S. Huyler died. His family forgave the Montreat debts to his estate. However, financial difficulties continued and the survival of the Mountain Retreat Association was again in question. In August 1910, the Montreat Managing Committee convened in Montreat to discuss the fate of Montreat. Dr. Robert Campbell Anderson, a member of the committee and pastor of the First Presbyterian Church of Gastonia, North Carolina, was charged with devising a plan to solve Montreat's financial difficulties.

On August 11, 1911, after successfully retiring the association's debt, Rev. Robert C. Anderson, at the age of 47, became its fifth president, a position he held for 36 years until his tenure ended on December 31, 1946. His wife, Sadie Gaither Anderson, was the only child of Thomas Bell and Betty Kelly Gaither. A resident of Charlotte, North Carolina, Thomas Gaither amassed a fortune in real estate at the turn of the 20th century. Many of the buildings seen in Montreat today were built with the financial support of Sadie Anderson and under the supervision of Dr. Anderson. Robert and Sadie Anderson had no children.

Montreat flourished under Presbyterian leadership, and by 1917, more than 140 homes had been built. Bible and mission conferences begun in 1897 continued to grow in attendance with the summer conference season typically lasting from late June until the end of August. In 1923, Montreat became the official conference center of the southern Presbyterian Church (PCUS). The most noted speakers of their day have spoken at Montreat, including Rev. Martin Luther King Jr., Rev. Billy Graham, and Rev. Peter Marshall. Rev. Billy Graham made Montreat his home after marrying Ruth Bell, the daughter of Presbyterian missionary and Montreat resident Dr. L. Nelson Bell. Rev. Peter Marshall was chaplain to the U.S. Senate in the 1940s and husband of Catherine Marshall, who wrote the novel *Christy*. As recounted in the early pages of this novel, "Christy" received her call to teach in the mountains of Appalachia after hearing a speaker at Montreat in the early 1910s.

The work of the church in Montreat began in earnest in 1923 with the General Assembly of the southern Presbyterian Church (PCUS) meeting in Montreat for the first of 24 times, almost every other year, prior to its reunion with the northern Presbyterian Church (UPCUSA) in 1983. Boardinghouses, hotels, and auditoriums were built to accommodate the thousands who came annually. The Montreat Normal School was opened in October 1916 with eight students to utilize these buildings during the winter months. In 1912, Robert Anderson and William Henry Belk purchased 28 acres in the heart of Montreat, where in 1925 they opened Camp Montreat for Girls. Camp Montreat, led by Alice Anderson "Macky" McBride of French Camp, Mississippi, in the 1930s and 1940s, brought girls from Florida, Mississippi, Texas, and surrounding states to the Montreat cove. The Woman's Auxiliary of the Presbyterian Church (US) held its organizational meeting in Montreat in 1912, and Montreat has been the recipient, wholly or in part, of four separate Birthday Offerings: (1) 1922, the Montreat Entrance Gate;

(2) 1936, the World Fellowship Hall; (3) 1941, the Collegiate Home; and (4) 1948, Howerton Hall. The first Birthday Offering was held in 1922 to celebrate the 10th anniversary of the Auxiliary. Then, as now, the denomination-wide Birthday Offering was used to fund specific projects meeting the worldwide mission of the church.

Major changes came to Montreat in the last half of the 20th century. In 1967, the Town of Montreat was incorporated in order to receive state funds for capital improvements. Swimming in Lake Susan ceased, and after 1970, gate fees were no longer required for entry to the conference grounds. In 1975, the Montreat Conference Center and Montreat College separated, each having its own president and governing organizations. As of 2008, the town of Montreat has some 600 houses and 730 residents, of which 340 are college students. Montreat College has 462 traditional students and a total enrollment of 1,100. The Montreat campus is the home of the world famous Ben Long fresco *The Prodigal Son*. The Montreat Conference Center now serves the reunited Presbyterian Church (USA) through its year-round program of church retreats and conferences.

The legacy of Montreat is supported by multiple organizations, including the Presbyterian Heritage Center, Montreat Patrons, Montreat Cottagers, Montreat Trail Club, Montreat Scottish Society, Montreat Adult Summer Club (founded in 1911 as the Woman's Co-operative Association), Friends of Music, Friends of the Library, and Montreat College Center for Adult Lifelong Learning (McCall). Community ties are built as friends and neighbors meet at the post office for their mail, as there is no postal delivery in Montreat.

In 2008, the Montreat Conference Center was inducted into the North Carolina Land Conservation Hall of Fame for deeding 2,450.79 acres of the Montreat cove into a permanent conservation easement, preserving the headwaters of the South Fork of the Swannanoa River and the beauty of unspoiled wilderness for generations to come.

From its beginning, Montreat has been a picture postcard perfect place and "a destination spot." It is with good fortune that the purchase of Montreat and its incorporation in 1897 coincided with the introduction of the picture postcard to the general public at the World's Columbian Exposition in Chicago, Illinois, in 1893. Almost everyone has either sent or received a postcard. Postcards are perhaps the original form of "text messaging." However, unlike electronic messages, postcards are tangible reminders of people, places, and events. They often serve as the best, if not only, visual record of times past. For over 100 years, visitors, conferees, residents, girls from the Normal School, and Montreat College students have sent postcards sharing their Montreat experience. Through a combination of studying card postmarks; identifying time specific images of buildings, cars, and dress shown in the cards; and by the manufacture of the cards themselves, we can, in this book, reach back in time and see Montreat as it was and as it has become. We hope you enjoy the journey.

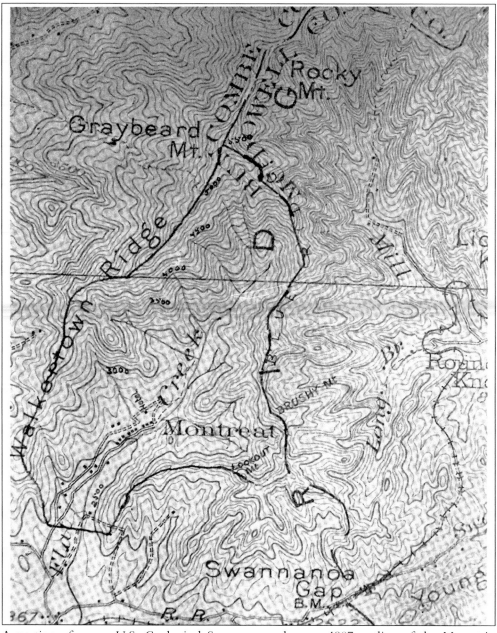

A portion of a rare U.S. Geological Survey map shows a 1907 outline of the Mountain Retreat Association's 4,500-acre boundary. (Courtesy of the Presbyterian Heritage Center at Montreat.)

One

Journey and Arrival

As one leaves Interstate 40 and turns north onto North Carolina Highway 9, through the town of Black Mountain, onto Montreat Road, and towards the mountains of the Seven Sisters, anticipation builds. Suddenly one is greeted by the sight of the stone arches of the Montreat Gate, marking the entryway into the special community of Montreat. Many mark their arrival and passage through the Montreat Gate by breaking out into song, heartily voicing "Montreat, how I love you, how I love you, my dear old Montreat." Incorporated in 1897 as the Mountain Retreat Association, it was soon found that this name was too cumbersome for everyday use. A new, shorter name was needed that would capture the essence of the beautiful mountain cove as well as the spirit of the fledgling endeavor. A contest was held, suggestions submitted, and a winning name announced. History leaves unclear who won. Frank Elwood Brown, an architect from New Haven, Connecticut, stated that he proposed the winning name to Rev. John Collins, the first president. In a separate account, Charles Rowland, one of the 15 founders, wrote that the winner was Jeannie Palmer, a teacher in nearby Valdese, North Carolina. However, the winning name itself was undisputed. In 1898, the Mountain Retreat Association became known forever as "Montreat." A special place to many in its more than 100-year history, Montreat has also been called "a mecca of Presbyterians," "a religious dream come true," "a place set apart," "the narthex of heaven," "the holy city," or "where God vacations." But to those who come to study, to attend a conference, to visit, or are called to stay a lifetime, Montreat is their own "Mountain Retreat."

In the winter months, Montreat is a small community. Drawn by the scenic beauty of the Blue Ridge Mountains and the programs at the Montreat Conference Center, summer months bring an influx of thousands. Residents and conferees gather for worship in Anderson Auditorium. Hikers and vacationers enjoy the more than 30 miles of trails in the 2,500-acre Montreat Conservation Easement. Families gather for reunions and hikes up Lookout Mountain. Old-time Montreaters reminisce, some recounting that "they came to Montreat before their mother gave birth, thus arriving in Montreat before they were even born." Old friends reunite, and new friends are made. These two 1923 Pennant Greeting Cards express the sentiments of the many who come to Montreat.

The community was chartered in 1897 as the Mountain Retreat Association. A shorter name was needed, and a contest was held. The winning name, "Montreat," a contraction of Mountain Retreat, was chosen in 1898. Large letter postcards were popular in the 1930s and 1940s, sending greetings and showing area highlights. In 1939, glimpses of the stone buildings, mountain streams, and the diving tower on Lake Susan are seen.

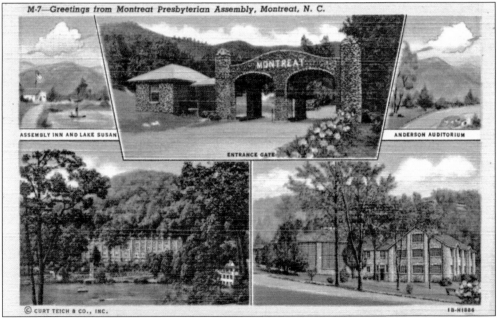

Sending "Greetings from the Montreat Presbyterian Assembly," this postcard shows the Montreat of 1941. The Assembly Inn overlooks Lake Susan, the gate welcomes arrivals, and Anderson Auditorium is the focus of the conference season. Scenes depicted by Curt-Teich Company postcards can be dated—the "A" series were published in the 1930s and the "B" series in the 1940s. The numeral in front designates the specific year.

Asheville, N.C., Looking up the Swannanoa Valley.

Montreat is located in the Swannanoa Valley (1906 view), 18 miles from Asheville and 2 miles from Black Mountain. Isolated by the steep rise of the Blue Ridge Mountains at its eastern boundary, the first European settler, Samuel Davidson, did not arrive in the Swannanoa Valley until 1784. Montreat was one of the last sections of the Swannanoa Valley to be settled, becoming a sheep ranch in 1888.

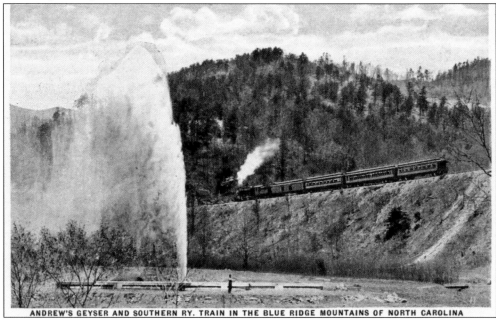

ANDREW'S GEYSER AND SOUTHERN RY. TRAIN IN THE BLUE RIDGE MOUNTAINS OF NORTH CAROLINA

The arrival of the railroad in 1879 opened up the Swannanoa Valley, attracting many looking for a healthier climate and seeking to establish religious assemblies. Montreat's founder, Rev. John C. Collins of New Haven, Connecticut, was both a Congregationalist minister and an officer of the International Christian Workers Association. His search for a place of recovery for those whose health had been compromised in Christian service ended at Montreat.

Southern Student Conference of Young Men's Christian
Associations, Montreat, N. C., June 11-20, 1909.

Asheville, N.C., Station of Southern Railroad

Montreat was offered for sale to Willis D. Weatherford for use as the YMCA assembly grounds around 1904. The offer was refused. Southern Presbyterians purchased Montreat in 1906, hosting a series of early YMCA conferences. Many YMCA conferees traveled to Montreat on the Southern Railway via Asheville. Travel by wagon between Asheville and Black Mountain was dangerous as the train track crossed the connecting roadway 14 separate times.

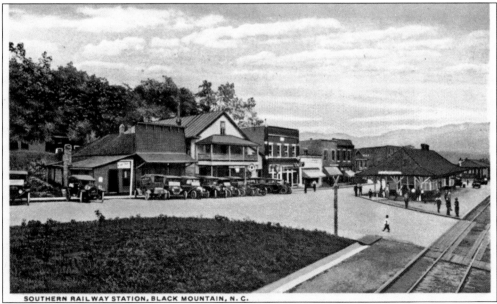

SOUTHERN RAILWAY STATION, BLACK MOUNTAIN, N. C.

Rail travelers to Montreat disembarked at the Black Mountain Station on Depot Street. Special religious conference rates were offered. In 1915, a ticket was good for 17 days and could be purchased for 3¢ per mile round-trip. Dr. Robert Anderson, traveling to raise funds for Montreat, often arrived at the station at 2:00 a.m., walking the long 3 miles to his Montreat home alone and in the dark.

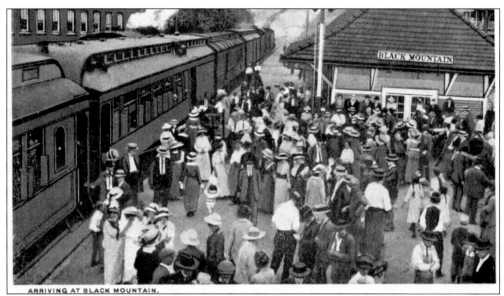

ARRIVING AT BLACK MOUNTAIN.

Multiple passenger trains stopped at Black Mountain each day with the principal trains arriving at 2:00 p.m. and 4:00 p.m. In 1911, Brown Brothers Livery promised dependable transportation to Montreat in substantial and comfortable turnouts (carriages). After almost 100 years, the last regularly scheduled Southern Railway passenger train ran from Asheville through Black Mountain to Salisbury, North Carolina, on August 8, 1975, and the era of passenger rail travel ended.

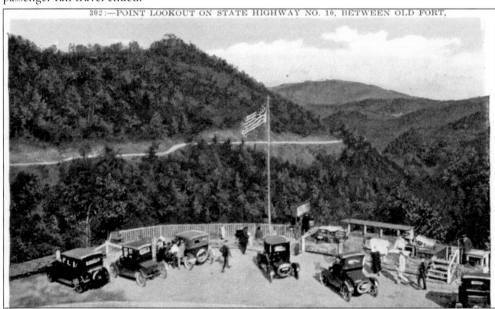

302:—POINT LOOKOUT ON STATE HIGHWAY NO. 10, BETWEEN OLD FORT,

Early travelers from eastern North Carolina drove their automobiles up the steep mountain from Old Fort, North Carolina, braving the hairpin curves of Highway 10 (old US 70). Their Model T's sometimes sported a license plate topper proclaiming their journey's end: "Montreat. Mecca of Presbyterians." Families made a welcome stop at Point Lookout, refilling the car's overheated radiators, enjoying the views of the Royal Gorge, eating hot dogs, and buying cokes for a bear named Sally.

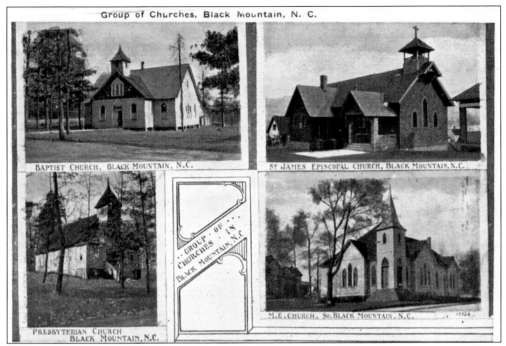

Group of Churches, Black Mountain, N. C.

BAPTIST CHURCH, BLACK MOUNTAIN, N.C.

ST. JAMES EPISCOPAL CHURCH, BLACK MOUNTAIN, N.C.

GROUP OF CHURCHES IN BLACK MOUNTAIN, N.C

PRESBYTERIAN CHURCH BLACK MOUNTAIN, N.C.

M.E. CHURCH, So. BLACK MOUNTAIN, N.C.

Upon arrival, travelers could attend one of a number of churches. The Black Mountain Presbyterian Church was organized in 1908, and Rev. Eugene L. Siler was installed as its first pastor in 1914. At the installation service, elder Dr. Isaac J. Archer of Montreat gave the charge to the congregation. For several years, Reverend Siler served the congregations of both the Montreat and the Black Mountain Presbyterian Churches. (SVM.)

On the Road to Montreat, N. C.

In 1920, the George M. Whitaker family resided on Montreat Road (1907 view). Hailing from Big Ivy, George and his wife, Kitty, moved to the area seeking work at Montreat and an education for their children. Their oldest daughter, Leonora, was the mother of Catherine Marshall. Leonora was the inspiration for Catherine Marshall's novel *Christy*, the fictionalized account of Leonora's call to teach in Appalachia. (BH.)

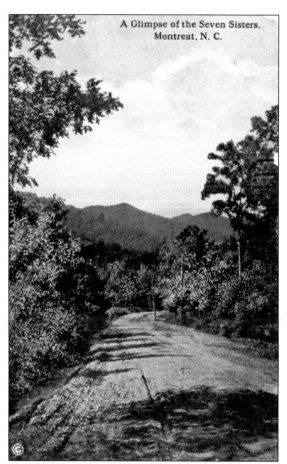

A Glimpse of the Seven Sisters, Montreat, N. C.

Approaching Montreat in 1916, one glimpses the 4-mile ridge of the Seven Sisters rising to frame the western boundary of the valley. Their official name is the Middle Mountain, as they separate the headwaters of the North and South Forks of the Swannanoa River. The settlers of the North Fork Valley, framed on the east by this mountain ridge, called them Walkertown Ridge.

As detailed by Perrin Wright, a third-generation Montreater and authority on local geographic place names, the major peaks of the Seven Sisters as viewed from Lake Tomahawk in Black Mountain are Tomahawk, Little Piney/Stomping Knob, an unnamed peak, Big Piney/Brushy Knob, Forked Ridge Knob, Little Slaty, and Big Slaty. (Graybeard is not one of the Seven Sisters.) In the early 1900s, the Solomon Morris family operated a dairy farm high on the Montreat slopes of the Seven Sisters (now the site of the Billy Graham home).

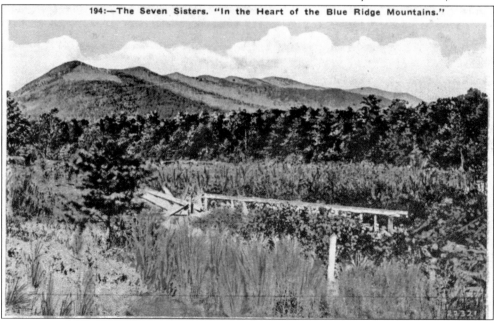

194:—The Seven Sisters. "In the Heart of the Blue Ridge Mountains."

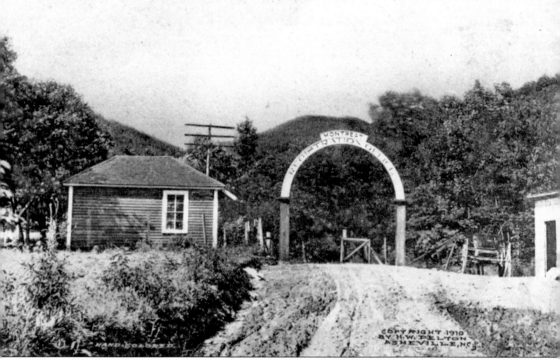

By 1903, the entrance to the Montreat Assembly Grounds was already marked with a wooden sign hung between two poles. Primarily serving as a boundary marker, the sign read, "Montreat, 1 1/2 Miles to the Station, 1 Mile to Assembly Ground." As there is only a single road into and out of Montreat, it soon became apparent that charging an entrance fee could raise revenue needed to support the conference center. A wooden archway and registration office were built, and a gated fence ran from the office and across the road all the way to Flat Creek. The arched wooden gate was torn down around 1910 and a barn-like structure designed to regulate the passage of wagons and horse-drawn hacks erected. Although fees were already being collected by 1910, the 1897 MRA Charter was amended to allow the collection of gate fees in 1913. A family pass for the season cost $9, not an insignificant sum as a week's stay for one at the luxury Montreat Hotel (Assembly Inn's predecessor) cost $15. (PHC.)

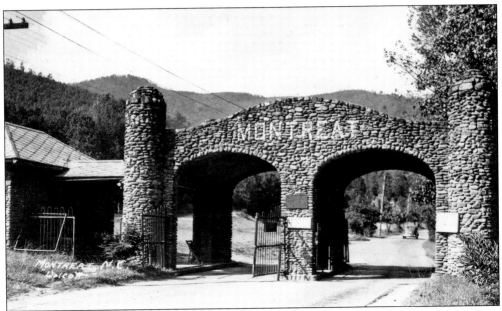

The present Montreat Gate was constructed in 1923. It was the gift of the Woman's Auxiliary of the Presbyterian Church. In 1922, the auxiliary celebrated its 10th anniversary with its first Birthday Offering. Twenty-six thousand dollars was raised for Miss Dowd's School for Girls in Japan, and $2,500 was used to build the Montreat Gate.

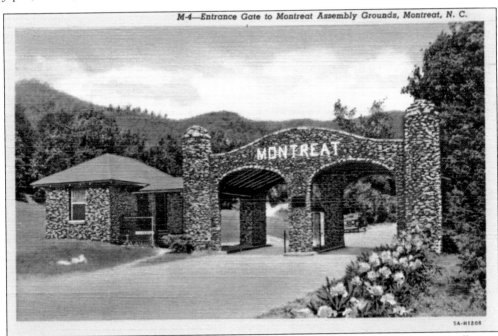

During the conference season, the gate was staffed by "gate boys," who lived in the small stone house connected to the gate. Gate boys collected fees, issued passes, and dealt with the public. Employment as a gate boy was a highly sought after and competitive position, often filled by carefully selected Davidson College students. Summer romances, and ensuing Montreat marriages, are known to have had their start at the gate.

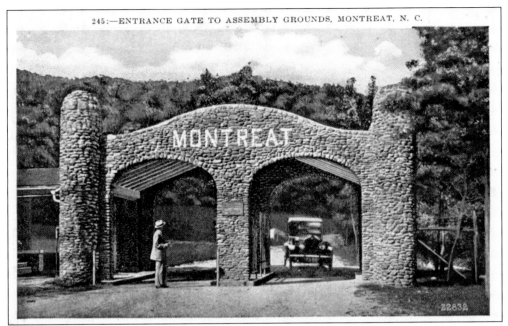

While the collection of gate fees became an accepted method for raising conference center funds, not all people were happy about the fees. Some cottage owners felt that they should not be charged for the privilege of getting to their own homes. In this quintessential postcard are the gate boy, the gate, and presumably a Presbyterian, ever the contrarian, running the gate and leaving Montreat through the entrance portal!

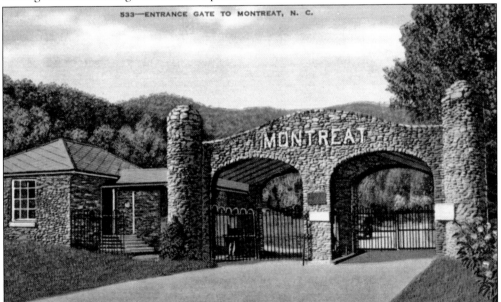

The Montreat gates were closed on the Sabbath except during worship services. The closed-gate policy presented a special challenge for couples getting married on a Sunday. One enterprising young couple solved the problem by leaving from the wedding ceremony in an ambulance. The gates were opened, and the newlyweds were off on their honeymoon before the gate boys realized that it was not a medical emergency.

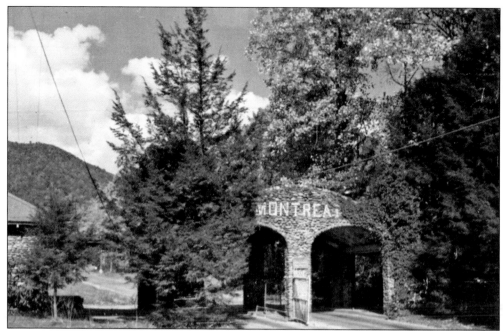

Let's take a tour of Montreat. The guide will be Ed DuPuy, a Black Mountain resident, member of the Black Mountain Presbyterian Church, founder of Highland Farms Retirement Center, a furniture maker, and a photographer. Son of a Presbyterian minister; brother of Monty DuPuy, a popular South Carolina television personality in the 1960s; and the father of a Presbyterian minister's wife, he is well qualified to lead this excursion.

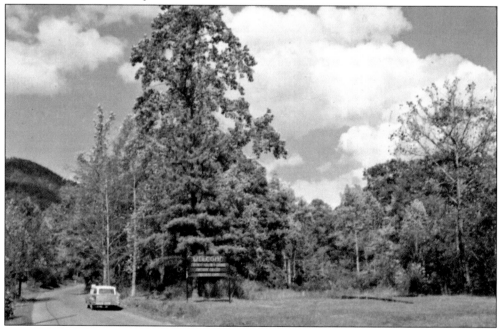

Traveling in Ed DuPuy's 1957 Chevrolet station wagon, the 1-mile journey along Assembly Drive from the gate to Lake Susan begins, passing the welcome sign on the right. Fifty years later, on May 26, 2007, the Nancy Holland Sibley Memorial Garden was dedicated near this site.

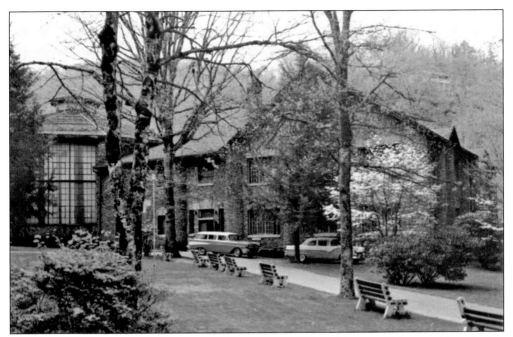

Arriving at Anderson Auditorium, note that even in 1957, parking could be a problem during the summer conference season. Creatively, the guide and the driver of a sedan have managed to solve this dilemma by parking on the auditorium grounds immediately adjacent to the side entrance door.

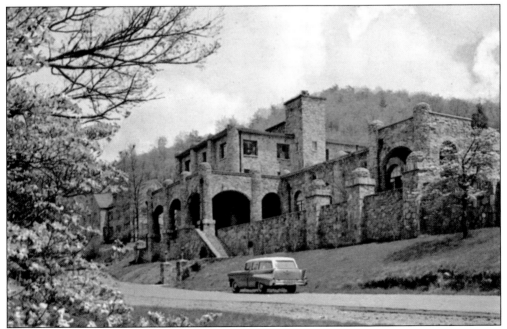

Continuing on the tour, parking in front of Howerton Hall is no problem at all. Although ready for occupancy in 1948, only two-thirds of the building, as originally designed, was ever completed. Howerton Hall currently houses a cafeteria and serves as a dormitory for Montreat College students in the winter and Montreat Conference Center conferees in the summer.

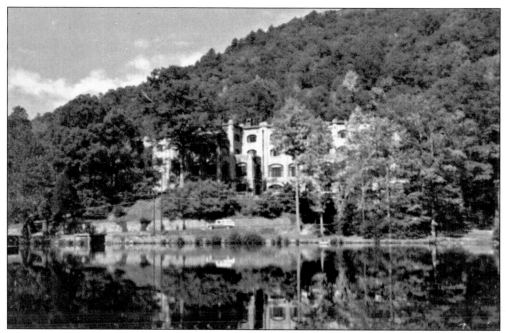

Arriving at the Assembly Inn, the guide parks above Lake Susan. The Assembly Inn is probably Montreat's most photographed building. This idyllic scene of the inn and the car, reflected in the lake, is now only a memory, never to be duplicated. Beginning in 2003, Lake Susan was drained, a leak in the dam repaired, and a memorial fence built above the banks.

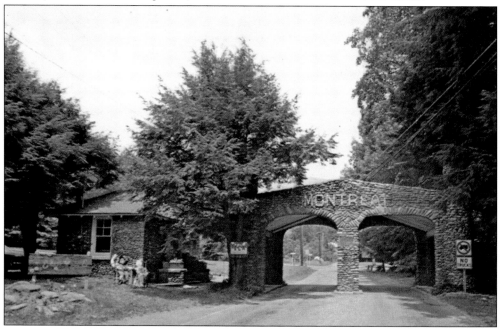

In 1967, the Town of Montreat was incorporated. In 1970, the collection of entrance fees ended, and the police department started using the gatehouse. It now serves as a Welcome Center with volunteers responding to such inquires as "Where does Billy Graham live?," "How far to Mount Mitchell? (not realizing Highway 9 ends at the gate)," and finally, "Just what IS Montreat?"

Two

Early Days and Building Years

Montreat is a town, a conference center, and a college. It is a community founded in 1897 on the ideals of physical, spiritual, and mental renewal and as a place for rest, restoration of health, recreation, education, Christian work, and fellowship. These statements reflect the stated goals of the North Carolina state charter granted to the Mountain Retreat Association on March 2, 1897. As envisioned, many of the first residents were in poor health when they arrived. The first permanent resident, Chester Case Lord, who came at age 41, was told he had but six months to live. He lived to be 86. A Christian Assembly was held within the first year with over 400 attending. A church was established and an orphanage built. For its first decade, the assembly was an interdenominational center, not purchased by the Presbyterians until 1906. However, the early Presbyterians continued the ideals of the charter. Under their leadership, conferences grew—over 12,000 arrived each conference season during the 1920s. Drawn by the mountains, Lake Susan, and the beauty of the stone structures, Presbyterians came from all over the South, building summer cottages and permanent residences. In 1904, there were some 33 residences in the valley; more than 140 were built by 1917. By 1950, the imposing stone buildings encircling Lake Susan were largely completed. Today more than 35,000 people pass through the gates annually and there are some 600 residences within the town limits.

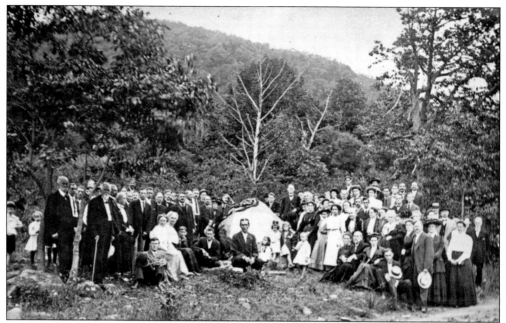

Dedicated in 1909, the Montreat Rock is located immediately inside the gate. It reads, "Montreat Founded by John C. Collins 1897." From New Haven, Connecticut, Rev. John Collins (second male from the left of the rock) stayed in Montreat for only two years, serving as president from 1897 to 1899. Reverend Collins was a Congregationalist minister, an officer of the Christian Workers Association, an early leader of the Boys Club of America, and the father of 10 children. (PHC.)

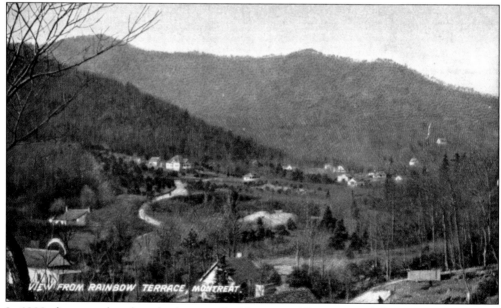

In 1888, sheep ranchers bought the cove for $1 an acre. The venture failed, and the ranch was sold in 1897 for $8 an acre to the Mountain Retreat Association. The ranchers cleared most of the valley floor, providing for homesites. As seen from Rainbow Terrace in 1909, the center curved road is Virginia Road and the topmost home, built in 1903, is named "Journey's Inn."

Mary Martin Miller (far right) was one of the first settlers. Much of what is known about the early days is from her 1898 letters. She arrived at age 27 in poor health, brought on by the stress of studies at Bryn Mawr and caring for her parents. She came only for a visit but stayed a lifetime, building a home, marrying, and raising three children.

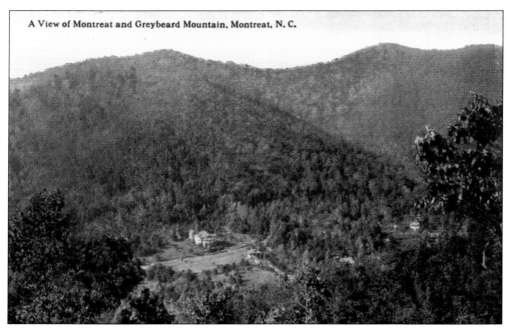

Mary Martin Miller writes that Asheville's mountains, while beautiful, seemed distant. Of the Montreat valley she says, "The mountains were so close that you could touch them two at a time." The writer of this 1915 postcard echoed that sentiment: "A safe and beautiful journey here, and I like the place. Quiet and shut in by the mountains but such sky and air and views. Lovingly, E.H.S."

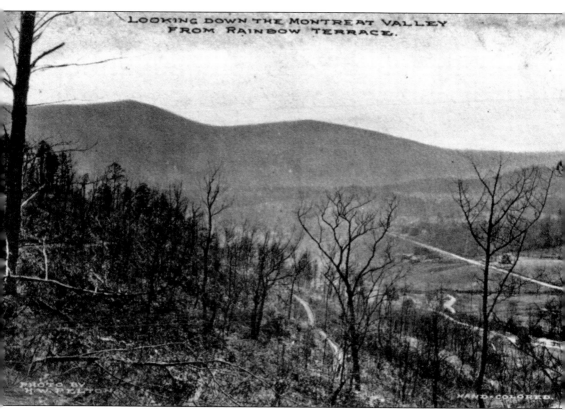

Here is a very different view of Montreat. Early Montreat winters were often bleak and bitterly cold. Montreat forests were cut to provide firewood, building materials, and revenue for the conference center. Many trees standing today are slightly over 100 years old, reflecting new growth after the failure of the sheep ranch and the early days of lumbering. Additional timber tracts were logged on Little Slaty and Rainbow Mountain around 1950. Hikers along Rainbow Road are retracing the old logging road. This desolate-looking scene is one of many cards published by Asheville's Herbert W. Pelton in the early 1900s depicting western North Carolina. The golden age of postcards was between 1906 and 1915. In 1907, over three-quarters of a billion postcards were mailed within the United States at a time when the country's population was only 90 million.

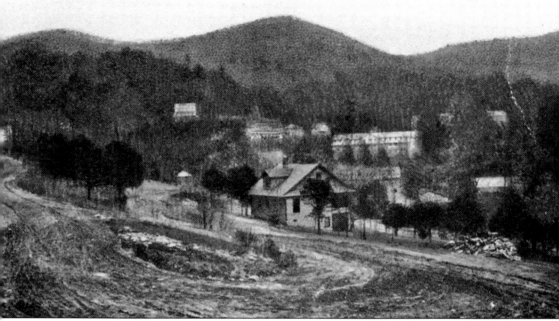

THE MONTREAT HOTELS—BRUSHY MT IN DISTANCE
MONTREAT. N C

Montreat had its own early resident photographer and postcard publisher, Alice Margaret Dickinson. Like many early residents, she was from the North, a "reverse snowbirder." An early advertisement stated that her postcards could be ordered in lots of 500 during the winter months from her home in Melrose, Massachusetts. In 1898, Mary Martin Miller wrote that a Dickinson family resided in Montreat. But was one of them Alice Margaret Dickinson? The message on this bleak 1915 postcard, near where the Heritage Center now stands, sheds some light on the mystery. Margaret D. writes, "I was supposed to return north last of September, but have been sick a little and so stayed another month. . . . It has been very cold. Am at work on photos still. Miss Adie Green [proprietress of Hickory Lodge] wished me to remember her and also the Lords [first permanent resident of Montreat]." Her postcards document Montreat's development from 1906 to 1922.

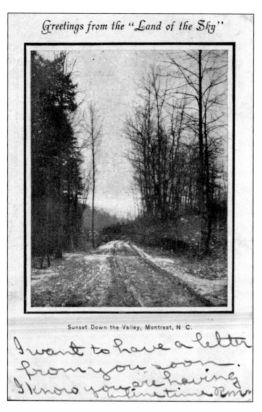

Greetings from the "Land of the Sky"

Sunset Down the Valley, Montreat, N. C.

I want to have a letter from you soon. I know you are having a fine time. Rm.

Looking from Robert Lake Park down Assembly Drive, "Sunset Down the Valley" depicts a 1906 winter view photographed by Margaret Dickinson. Postcards can be dated by manufacturing characteristics. Prior to 1907, messages could only be written on the front of the card, with the entire rear reserved for the address. After 1907, the right rear side was for the address, and the left rear side was for the message.

Hikes to the viewpoint on Lookout Mountain have been a Montreat tradition for generations. Getting there, though, has not always been easy, as early streets were often muddy and deeply rutted. Montreat's pioneer settlers regarded the 2 miles separating Black Mountain and Montreat an arduous journey after a heavy rain, with wagons sinking to their hubs in the mud.

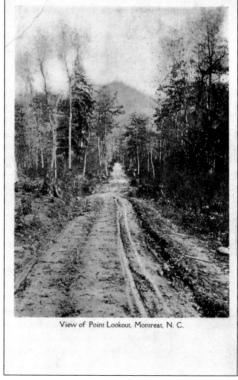

View of Point Lookout, Montreat, N. C.

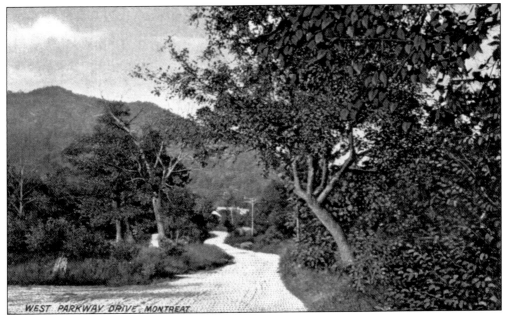

West Parkway Drive, Montreat

In 1909, the road following Flat Creek from the gate to the center of the assembly grounds was known as West Parkway Drive rather than Assembly Drive. Many Montreat street names reflect the Synod and Presbytery names of the Presbyterian Church. The only street name remaining from Frederick S. Odell's 1898 survey map is Yale Road, reflecting Montreat's connection with New Haven, Connecticut.

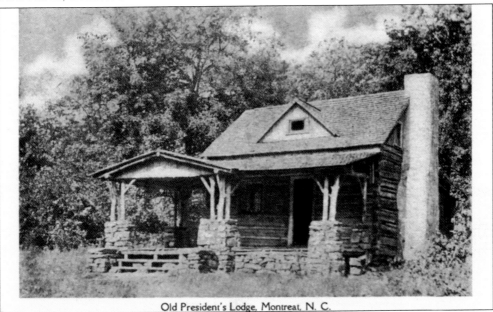

Old President's Lodge, Montreat, N. C.

The chimney of the old President's Lodge stands today near the corner of Assembly Drive and Louisiana in the front yard of the home purchased by Dr. L. Nelson Bell and his wife, Virginia, China missionaries and parents of Ruth Bell Graham. Dating from the sheep-ranching era and originally planned for use as Rev. John Collins office, the cabin was "fixed-over" and rented to the Saleno family from Chicago in 1898.

31

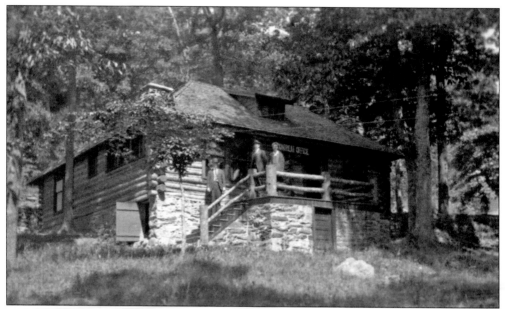

After selling to the ranchers, Anderson Kelly built a one-room log cabin 1 mile farther up the valley. In 1911, it became the Montreat Office. Pictured are Albert R. Bauman (left), assistant manager from 1913 to 1943; Dr. Robert C. Anderson (center), president from 1911 to 1946; and Annie R. Hudson (right), secretary from 1911 to 1947. Known as "The Force," they guided Montreat during 30 years of growth and building. (PHC.)

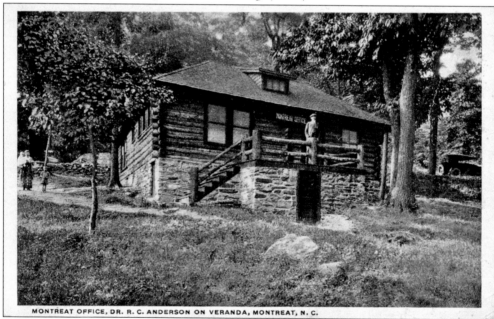

MONTREAT OFFICE, DR. R. C. ANDERSON ON VERANDA, MONTREAT, N. C.

The brass plaque on the grounds of the auditorium honoring Dr. Robert Anderson reads: "If You Seek His Monument Look Around." With Dr. Anderson functioning as a self-described committee of one, it was during his tenure as president that the physical development of Montreat largely took place. The stone structures of Assembly Inn, Anderson Auditorium, Gaither Hall, and Howerton Hall are but part of his legacy.

Serving as the Montreat Office for over 50 years, the log cabin stood above the banks of Lake Susan near Assembly Inn, approximately where Convocation Hall is today. It was torn down in the 1960s. From his vantage on the veranda, in 1920, Dr. Anderson could look through the trees towards the lake, viewing strollers along the shore and boating on the lake.

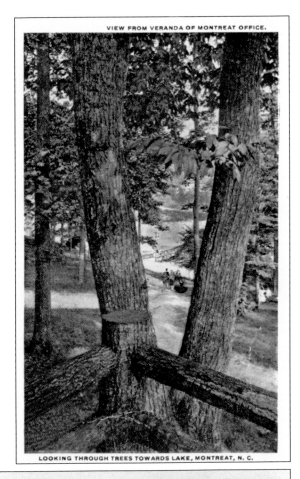

VIEW FROM VERANDA OF MONTREAT OFFICE.

LOOKING THROUGH TREES TOWARDS LAKE, MONTREAT, N. C.

The lake, 1 mile from the entrance gate, has long been both the physical and social center of Montreat. The 1898 survey map prepared by Frederick Odell shows a proposed lake, as does the 1906 survey map commissioned after the Presbyterian purchase. By 1915, boaters enjoyed the lake while spectators with their parasols watched from the shore and the earthen and wooden dams.

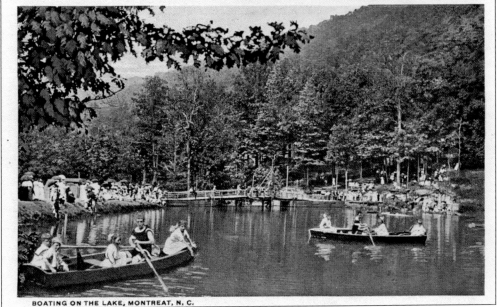

BOATING ON THE LAKE, MONTREAT, N. C.

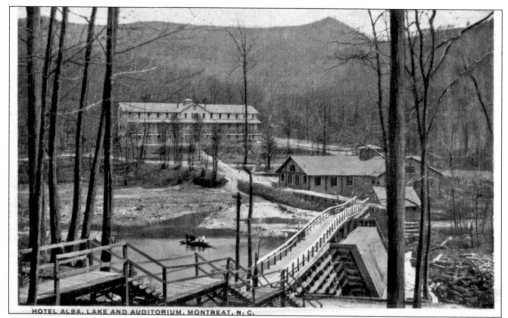

HOTEL ALBA, LAKE AND AUDITORIUM, MONTREAT, N. C.

William Church Whitner, a Rock Hill, South Carolina, resident and Montreat cottager in 1906, designed the wooden dam. As civil engineer for Anderson, South Carolina, in 1895, he brought electricity to that city from a power plant on the Rocky River some 6 miles away, and Anderson became known as "The Electric City." At first, Whitner's wooden and earthen dam failed to hold, but early repairs fixed the leaks and the 3-acre lake was formed. However, the dam could not withstand the dual hurricanes of July 8 and July 15, 1916. Torrential rains came on the 15th with 22 inches falling in 24 hours. The dam gave way on July 16, 1916, overwhelmed by the rainfall and run-off water from grounds already saturated by the earlier hurricane. The garage and the bridges below the dam were destroyed at a capital loss of $5,000. There was no loss of life in Montreat. The rainfall in Asheville for July 14–16 was only 2.85 inches. (Below, PHC.)

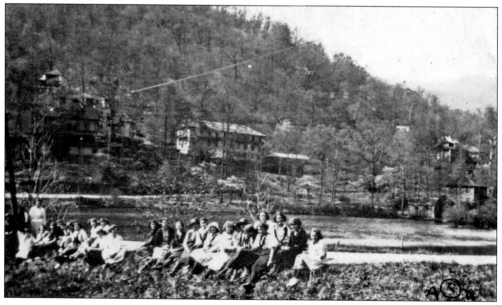

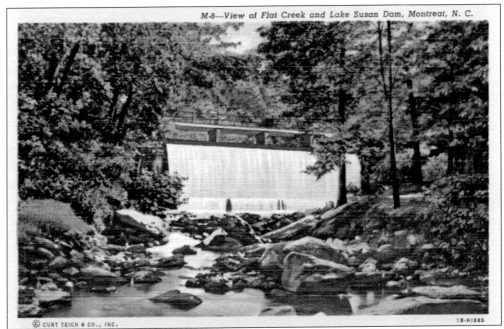

© CURT TEICH & CO., INC. 1B-H1885

The wooden dam was rebuilt, but a new dam was still needed. In 1924, a concrete dam was built across Flat Creek. It was also designed by William Whitner. Funds were donated by Mrs. Charles E. Graham and her son Allen, of Greenville, South Carolina. Mrs. Graham was named Susan, as were her mother, her daughter, and her granddaughter, thus the Montreat lake became Lake Susan.

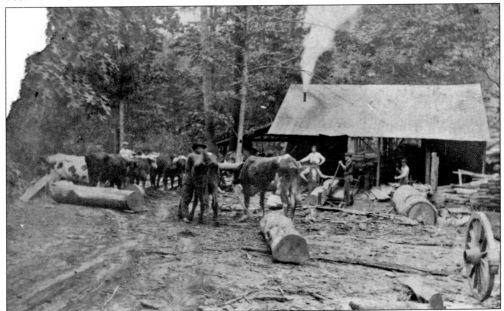

Homes and conference buildings were constructed using Montreat timber. The sawmill operated near the present site of Anderson Auditorium. The story is told that upon donating the funds for the concrete dam, Susan Graham wanted the sawmill removed since her house (now Georgia Lodge) was across the road. (RN.)

35

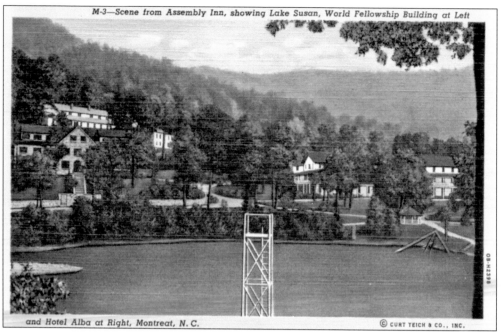

M-3—Scene from Assembly Inn, showing Lake Susan, World Fellowship Building at Left
and Hotel Alba at Right, Montreat, N. C.

© CURT TEICH & CO., INC.

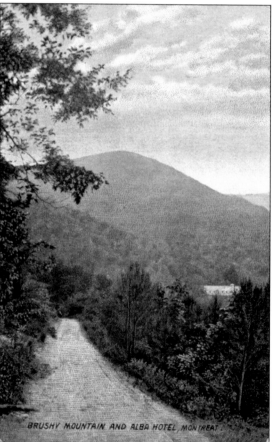

BRUSHY MOUNTAIN AND ALBA HOTEL MONTREAT

As Dr. Robert Anderson stood on the veranda of the Montreat Office in 1940, he had a new view. A diving tower looming high over Lake Susan provided exciting sport, there were many new buildings, and the sawmill in front of Anderson Auditorium was gone.

The Blue Ridge Mountain range forms the valley's northeastern border. The eastern continental divide runs along its crest, sending Montreat waters to the Gulf of Mexico. This prompted Rev. Walter W. Moore, Union Seminary president (1904–1926), to extol: "In some respects Montreat reminds us of ancient Jerusalem . . . Jerusalem is 2,600 feet . . . the elevation of Montreat is exactly the same. Jerusalem is on the watershed of Palestine . . . so Montreat sits on the great watershed of Eastern America."

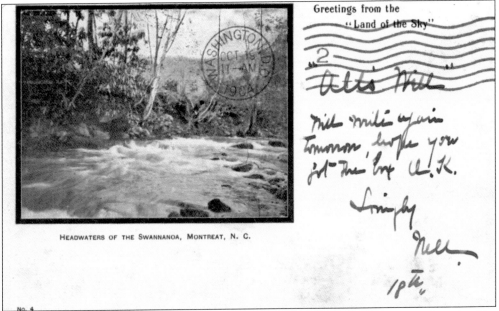

HEADWATERS OF THE SWANNANOA, MONTREAT, N. C.

Water is a treasured resource and a coveted commodity. The headwaters of the North Fork of the Swannanoa River are located in the North Fork Valley, and the headwaters of the South Fork (pictured above in 1904) are located in the Montreat valley. By 1903, Asheville was acquiring property in the North Fork Valley, and the Burnett Reservoir was built in 1950. Montreat residents built their first water reservoir in 1911 on Big Piney Mountain. A second intake was built on Puncheon Branch flowing along Lookout Road. The third was built in 1951 at the top of Greybeard Trail. Three holding ponds were built to provide electricity (1913–1921). The hydroelectric plant was located near the current Montreat campground. In 1947, Carolina Power and Light began supplying electricity, and in the 1980s, the town installed a well-based water system. (Below, BH.)

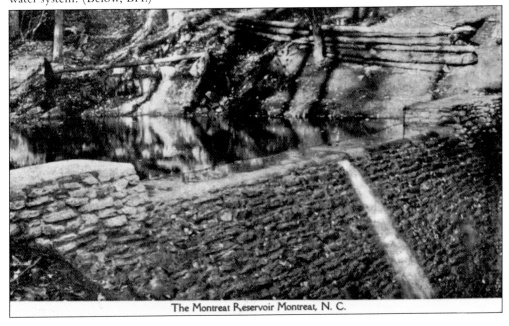

The Montreat Reservoir Montreat, N. C.

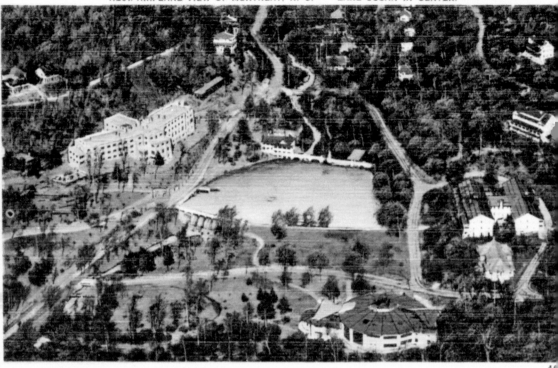

Montreat's signature buildings (some now gone) were built around Lake Susan. In a clockwise fashion are the Assembly Inn, the old Montreat Hotel annex, the Lakeside Building, the Boy's Club, the Alba Hotel, the Foreign Mission Building, and the 1922 Anderson Auditorium. The inn was completed in 1929, and the annex burned in 1931, dating this view to approximately 1930.

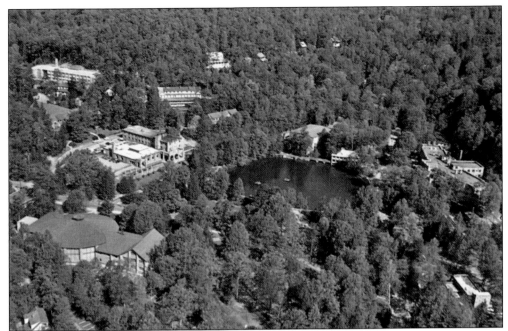

Sometimes, postcards pose a problem. These two panoramic views of Montreat in the 1960s are puzzlingly dissimilar, but they are, in fact, mirror images of each other. The card with Anderson Auditorium on the far left (above) is a mirror image view of Montreat. Do not worry. All is right with the world, as the lower card with Anderson Auditorium on the far right shows Montreat correctly oriented. Three new buildings now ring Lake Susan. Looking closely, one can see: McAlister Gymnasium dedicated August, 1958, as part of Camp Montreat, to the right of the Lakeside Building; Howerton Hall (right center), which replaced the Alba Hotel, destroyed in 1946; and the new Anderson Auditorium (lower right), rebuilt in 1940.

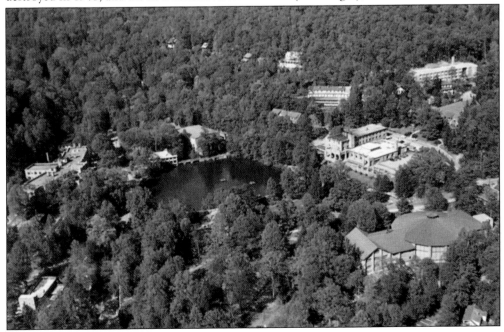

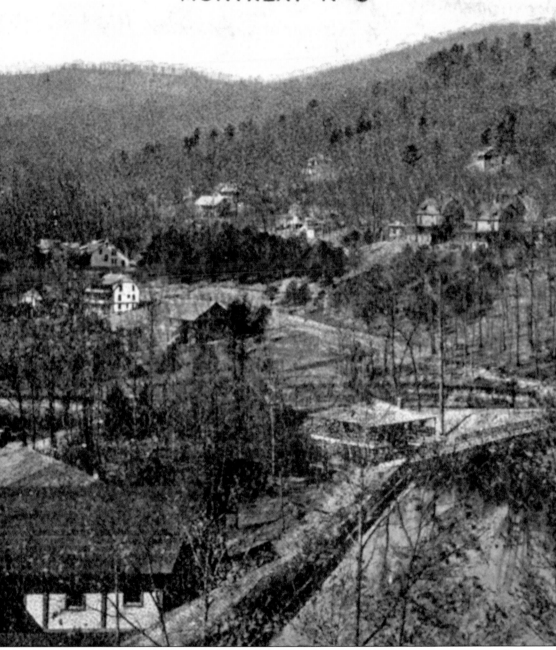

It has been written that the stories of Montreat reside in its houses. Saved in a young girl's 1915 scrapbook, this view, taken across the lake from the Alba (now the site of Howerton Hall), shows the homes of many who served Montreat. Telling but one story, the hip-roofed house with double porches, seen on the far middle left, was built in 1897 by Chester Case Lord. Located on Georgia Terrace, it is Montreat's oldest structure, now called Chestnut Lodge. The descendent of Abraham Pierson, Yale's first president, Chester Lord, age 41, was working in a New Haven

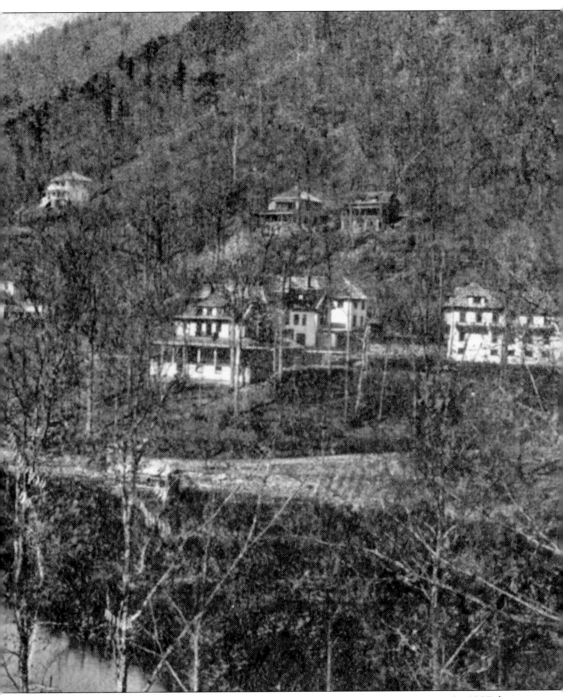

hardware store when his doctor gave him six months to live. Moving to Montreat in 1897, he became its first permanent resident. He ran a boardinghouse in his home, sold fire insurance, managed a store, served as postmaster (1922–1932), was an elder in the church (1914–1942), supervised the building of the first auditorium and dam, and was the father of physician Dr. Margery Lord, the first female health official in North Carolina. He lived to be 86.

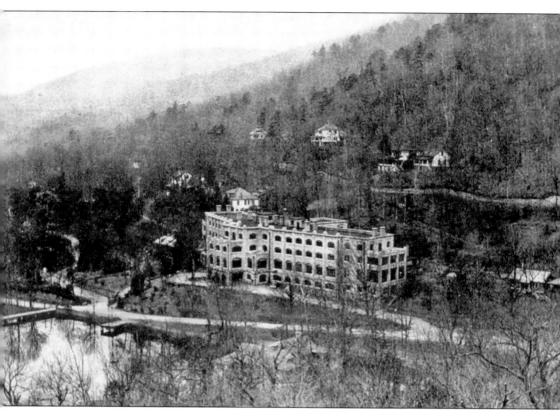

More than 140 homes were constructed by 1917. Homesites were selected in an unusual fashion. In order to finance the new venture, the Mountain Retreat Association sold stock to individuals for $50 a share. This entitled the stockholder to lease a lot for 99 years. On August 31, 1898, lot selection was determined by a drawing. Each stockholder was entitled to select a lot in the order of which his or her name was drawn. A second stock sale (purchase price $100) and drawing of lots was held by the Presbyterians in January 1907. The drawing and the selection were done on the same day, presenting a picture of Presbyterians used to doing things: "decently and in order" scurrying about Montreat to find the perfect lot. These 99-year leases were converted to individual ownership in the early 1920s. Many of these houses, as viewed around 1940 from the South Carolina Home, were built on the southeastern slopes of the Seven Sisters to take advantage of the warm morning sun and the fact that a 2-inch waterline ran along the mountainside. (JLSVM.)

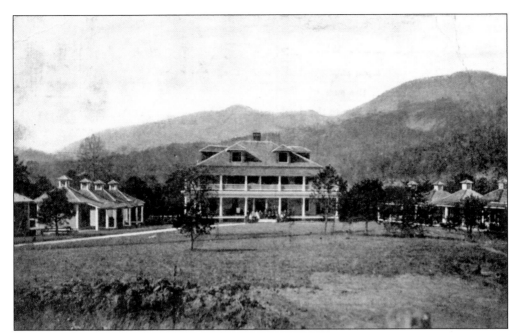

A Montreat resident, Dr. Isaac J. Archer, originally from Chicago, was the director of the Royal League Tuberculosis Sanatorium founded in the North Fork Valley in 1904. In 1913, Dr. Archer suggested to world-famous musicians Crosby and Juliette Adams that they retire from Chicago to Montreat. The 200-acre Rocky Knob Tract, purchased by the Montreat Cottagers Association in the early 1990s and placed into a conservation easement, once belonged to Dr. Archer.

Like others, Will Bailey came to Montreat to recover. On July 11, 1917, he wrote to Etta Odom of Marion, North Carolina, "Dearest friend . . . I could walk to the post office better yesterday than I could Monday. It is real cool this am, feels like we need a fire. Got my huckleberries and got them canned . . . Your dearest friend, Will."

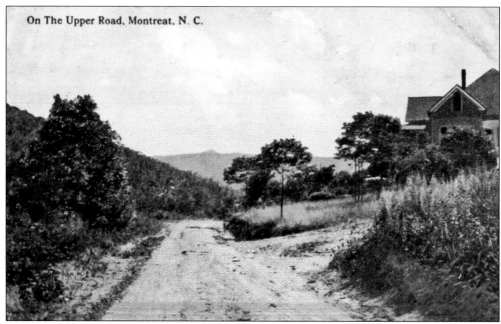

On The Upper Road, Montreat, N. C.

The house partially seen on the right is a prominent feature in many postcards and is easily identifiable due to its large size and distinctive architecture; thus, "The Upper Road" can be identified as Virginia Road. Harry and Blanche Hurd Constantine built the house, at 119 Virginia Road, in 1903. Originally from Amherst, Massachusetts, Blanche arrived in 1898 and purchased four lots. Single when she arrived, she met and married Harry, a local builder. Their showcase home was featured prominently in 1907 marketing campaigns. In 1911, the house was sold to Daniel A. Tompkins, the founder of the *Charlotte Observer* and famous for bringing cotton mills to the south. A bachelor, he died at the home in 1914. It became a boardinghouse called Journey's Inn before the Barker family purchased it in the 1960s.

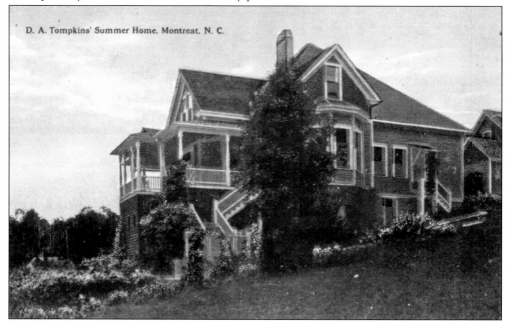

D. A. Tompkins' Summer Home, Montreat, N. C.

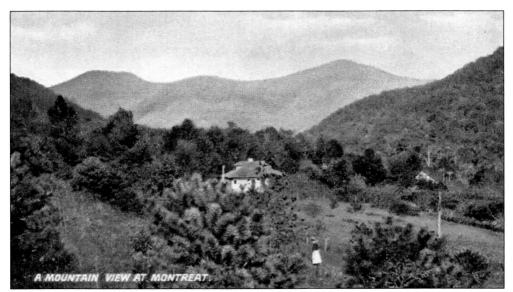

This 1908 view shows "Whispering Pines." Sitting on the mountain slopes at 120 Virginia Road, it was the first home built on the right side of the street. A symmetrical jewel-box of a home, sisters Carrie and Isabel Whallon were the builders and occupants, coming from Candler, North Carolina, to establish the Montreat orphanage. The orphanage on Oak Lane burned on January 21, 1905. Supposedly, the fire was started by a child hoping for new clothes and toys.

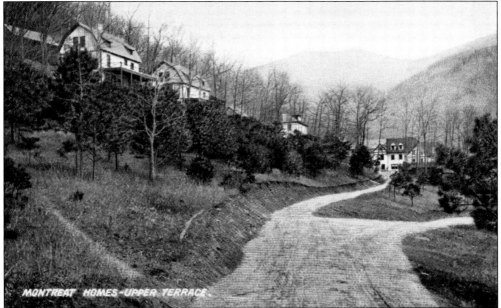

The Upper Terrace can be as identified as North Carolina Terrace by the twin houses of W. J. (Papa Joe) Roddey and his brother-in-law William Whitner. W. J. Roddey was instrumental in bringing Winthrop College to Rock Hill, South Carolina, in 1895. Winthrop was founded in 1886 in a chapel at Columbia Theological Seminary, located in Columbia, South Carolina, at that time. The extended Roddey family built seven homes on North Carolina Terrace before 1918.

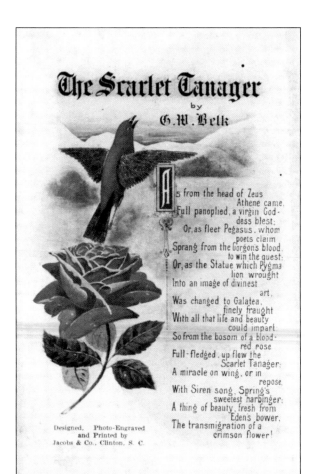

The Scarlet Tanager
by
G. W. Belk

As from the head of Zeus
Athene came,
Full panoplied, a virgin God-
dess blest;
Or, as fleet Pegasus, whom
poets claim
Sprang from the Gorgon's blood,
to win the quest;
Or, as the Statue which Pygma
lion wrought
Into an image of divinest
art,
Was changed to Galatea,
finely fraught
With all that life and beauty
could impart.
So from the bosom of a blood-
red rose
Full-fledged, up flew the
Scarlet Tanager;
A miracle on wing, or in
repose,
With Siren song, Spring's
sweetest harbinger;
A thing of beauty, fresh from
Edens bower,
The transmigration of a
crimson flower!

Designed, Photo-Engraved
and Printed by
Jacobs & Co., Clinton, S. C.

Rev. George W. Belk was minister at Montreat Presbyterian Church from 1921 to 1924. The rear side of this advertising card reads, "By courtesy of the gifted author, Rev. Geo. W. Belk of Montreat, we are permitted to present to you this beautiful poem, 'The Scarlet Tanager.' The designing process, photo-engraving and color process are from the Graphic Arts Division of JACOBS & CO., CLINTON, SC."

Sam Belk, the son of Reverend Belk, was a ham radio operator. On August 5, 1926, Sam posted a card to a fellow operator in Minneapolis after connecting over the airwaves. The card described his equipment and gave his call sign "4RY." Prior to the Radio Act of 1927, geographic call districts were designated by a numeral with Montreat being in District 4.

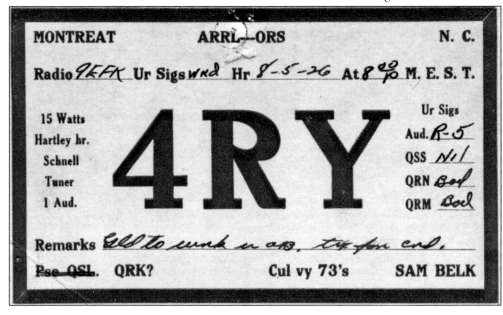

MONTREAT ARRL—ORS N. C.

Radio 9EFK Ur Sigs wxd Hr 8-5-26 At 8 00/10 M. E. S. T.

15 Watts
Hartley hr. Ur Sigs
Schnell Aud. R-5
Tuner QSS N/1
1 Aud. 4RY QRN Bod
 QRM Bod

Remarks Gld to wnk u ab, tx fer crd,

Pse QSL. QRK? Cul vy 73's SAM BELK

Nestled in the woods at 221 Assembly Drive, this cottage was purchased by Louis C. and Sarah Hunter LaMotte on August 16, 1939. A postcard drawing of the cottage named "Acadie" is postmarked 1916, and the year 1916 can also be found on the claw-foot tub, dating construction to the early 1900s.

History leaves no record of the Millers. Built in 1909, "Shadynook" (439 Greybeard Trail) was purchased in 1936 by Annie Muller English Walker and her husband, Rev. John Mack Walker Sr., for $1,500. Their son, Rev. John Mack Walker Jr., carved a series of wood sculptures retelling Gospel stories through the images of the Appalachian mountain people. These can be seen at the Presbyterian Heritage Center at Montreat.

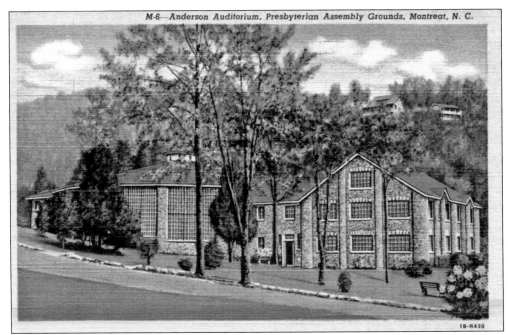

In 1915, Rev. John Wilbur Chapman built a home above the present site of Anderson Auditorium. Twice called as pastor of Philadelphia's Bethany Presbyterian Church, Reverend Chapman helped the church grow. In 1898, over 6,000 people attended its Sunday school. Chapman led thousands to Christ through his evangelical crusades. Chapman's own call to evangelistic ministry was reaffirmed during conversations with Dwight Moody. Chapman hired Billy Sunday, a professional baseball player, to work in his crusades. Billy Graham lists each of these three as among his "theological forefathers."

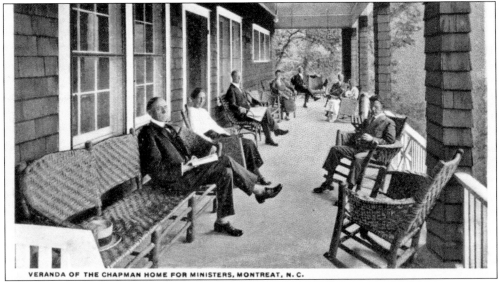

VERANDA OF THE CHAPMAN HOME FOR MINISTERS, MONTREAT, N. C.

The Chapman home was built as three separate structures: a large main house, a kitchen and dining space, and a carriage house. Charles Alexander, a frequent visitor to the home, was the director of music for the Chapman crusades and editor of the 1916 Montreat Hymnal, writing in its preface that "children get their theology from the hymns they sing."

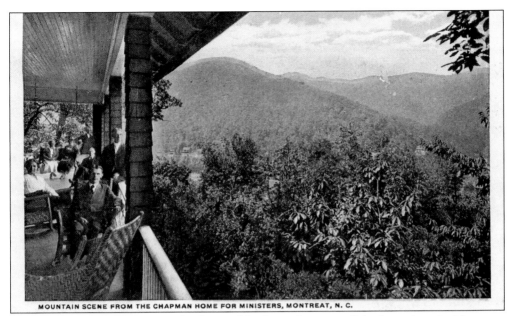

MOUNTAIN SCENE FROM THE CHAPMAN HOME FOR MINISTERS, MONTREAT, N. C.

The expansive porch spanning the front of the house has one of the best views in Montreat. Reportedly, it was on this porch that Harry Barraclough, pianist for the Chapman crusades (1914–1917), composed the hymn "Ivory Palaces" in 1915, moved by a sermon just preached by Reverend Chapman. The sermon text was based on Psalm 45:8, "All thy garments smell of myrrh, and aloes, and cassia, out of the ivory palaces."

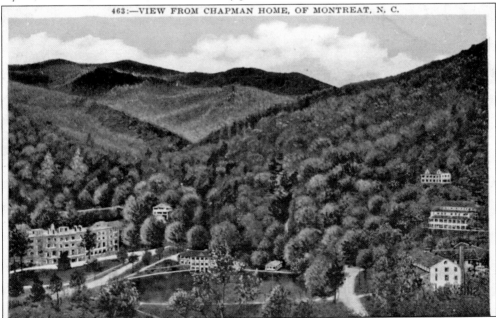

463:—VIEW FROM CHAPMAN HOME, OF MONTREAT, N. C.

Rev. John Wilbur Chapman composed hymns, was president of Moody Bible Institute, moderator of General Assembly, a Presbyterian pastor, and an evangelist. He died in 1918 at age 59, having preached more than 50,000 sermons to more than 60 million people around the world. The Chapman home, with its expansive view, was donated in 1919 for use as a home for ministers and missionaries.

A FAVORITE STROLL AT MONTREAT

Despite ever-present financial concerns, Montreat, Swannanoa Valley's first religious assembly, grew and flourished. The fruits and labors of the early days and building years are enjoyed in the quiet mountain beauty as this couple strolls along Missouri Road. Today new residents, sixth-generation Montreaters, conferees, college students, and visitors all enjoy the foundation established by those who came before, fulfilling the tenets of the original 1897 charter. (RN.)

Three

RAILROADING IN MONTREAT

For many years, Montreat hikers have enjoyed the Trestle Road trail in the Montreat wilderness. The intriguing history of this trail has its roots in the commercial timber and tourist operations of the early 1900s. In 1911, logging companies obtained the timber rights to large tracts of spruce and fir forests in the Black Mountains surrounding Mount Mitchell. Clarence A. Dickey and Joseph C. Campbell obtained rights to 9,000 acres. In 1912, Dickey, Campbell, and Company established a large double-band sawmill 1 mile east of Black Mountain. This mill could process 110,000 board feet of lumber per day. In order to transport the potential 200 million board feet of spruce and fir down to the mill, a narrow-gauge railroad was built using donkeys, dynamite, and manual labor. This railroad was completed in one year and consisted of 3 trestles, 9 switchbacks, and 18 miles of track and gained 3,500 feet in altitude. When Judge James D. Murphy resigned as president of the Mountain Retreat Association in 1911, he had already negotiated a contract for the railroad right-of-way for 6 miles through Montreat, but it was not signed. When Dr. Robert C. Anderson became president in 1911, he signed it with the added clause that the right-of-way would revert to Montreat when the logging operation ended. The contract was for $500 per mile access and 15¢ per cross tie, with Montreat retaining the timber rights. In 1913, Frederick A. Perley and William H. (Bert) Crockett bought out the logging contract from Dickey and Campbell. From 1913 until 1919, the Perley and Crockett Lumber Company added passenger cars on the Mount Mitchell logging railroad for tourist access to Mount Mitchell. Logging operations ceased in 1921, and the Mount Mitchell Development Corporation proposed a tourist motor toll road on the abandoned rail bed. Dr. Anderson successfully won a lawsuit in the courts upholding the right-of-way reversion. Therefore, the Trestle Road within the Montreat boundaries was preserved and the Mount Mitchell Motor Road was forced outside the Montreat boundaries. The now abandoned motor road is also accessible to hikers as the Toll Road.

MT. MITCHELL, ALTITUDE 6717 FT., ASHEVILLE, N. C.

Mount Mitchell is the highest peak in the eastern United States and has enjoyed tourist access for over a century. Over the years it has been accessed from Black Mountain and Montreat by hikers, by the Mount Mitchell Scenic Railroad (1913–1919), the Mount Mitchell Motor Road (1922–1939), and from the Blue Ridge Parkway (1939).

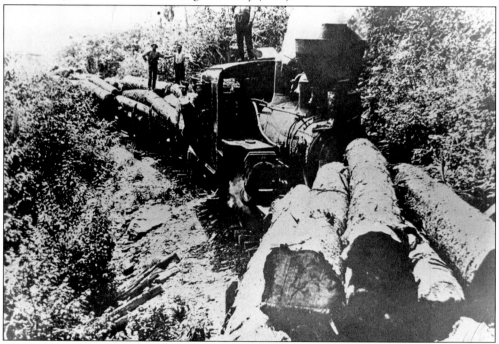

Dickey, Campbell, and Company obtained logging rights to 9,000 acres of spruce and fir in the Black Mountains. They built the Mount Mitchell narrow-gauge railroad from Black Mountain in 1911 and 1912. In 1913, the Perley and Crockett Company bought the business. The railroad had 6 miles of right-of-way through Montreat.

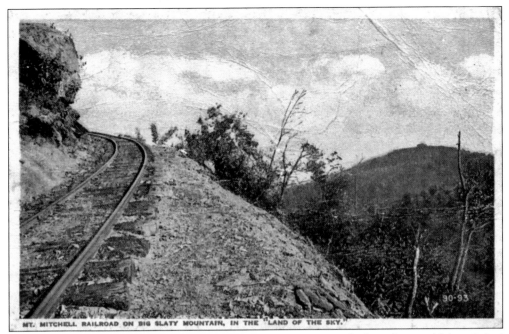

The narrow-gauge railroad was built using mules, dynamite, and a lot of manual labor. It had three trestles, nine switchbacks, and gained 3,500 feet of altitude on the way from Black Mountain to below the summit of Mount Mitchell. The railroad was completed in 364 days. Logging occurred from 1912 until 1921 and up to 250 million board feet of lumber was harvested.

Through the Primitive Forest, on the trail to Mitchell. "In the Land of the Sky."

The vast acreage of spruce and fir cut on the slopes of the Black Mountains and the subsequent fire, erosion, and water damage was the primary impetus for Gov. Locke Craig, state forester John Simcox Holmes, and others to call for the establishment of Mount Mitchell State Park in March 1915. Four acres at the summit of Mount Mitchell had not been cut.

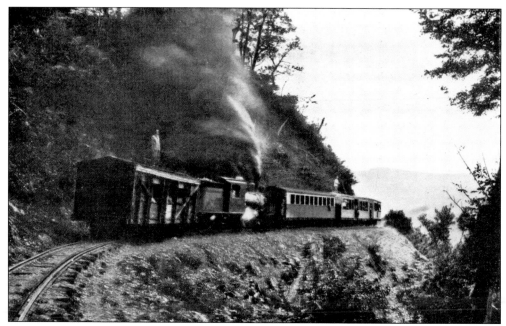

As part of the Montreat railroad right-of-way agreement in 1911, the logging company paid for access rights and cross ties used within the Montreat boundaries. A contract addendum by Dr. Robert Anderson specified reversion to Montreat after logging was completed.

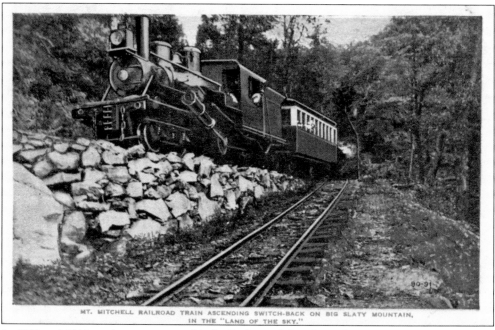

MT. MITCHELL RAILROAD TRAIN ASCENDING SWITCH-BACK ON BIG SLATY MOUNTAIN, IN THE "LAND OF THE SKY."

In 1913 and 1914, under new ownership by Perley and Crockett, the Mount Mitchell Railroad added two crude passenger cars and made special passenger runs on the logging railroad. In July 1915, the passenger rail service officially opened. (RN.)

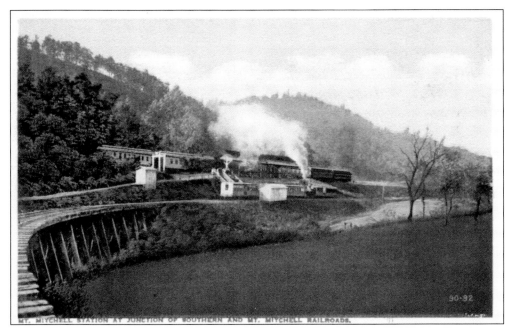

The Mount Mitchell passenger station was dedicated in August 1915. It was near the sawmill, 1 mile east of Black Mountain. The station allowed the interchange of passengers between the narrow-gauge Mount Mitchell Scenic Railroad and the standard-gauge Southern Railroad.

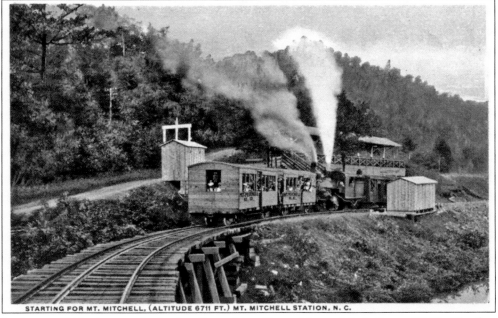

In August 1915, the round-trip fare from Asheville to Mount Mitchell was $2.50. The fare included a hot meal on the mountain as well as 4 hours at the summit. The trip was 21 miles long and took 3 hours on the ascent and 3.5 hours for the descent. At its peak, the railroad carried as many as seven cars and 250 people per trip.

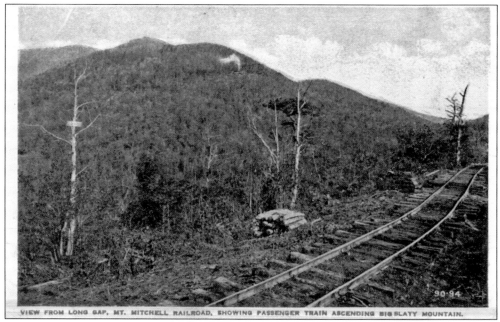

VIEW FROM LONG GAP, MT. MITCHELL RAILROAD, SHOWING PASSENGER TRAIN ASCENDING BIG SLATY MOUNTAIN.

This scene from Long Gap in Montreat shows how few trees obstructed the views from the train. Looking carefully, one will also see a puff of smoke across the valley as a train ascends Big Slaty Mountain on the switchbacks. Note the wooden sign nailed on the tree identifying Slaty Mountain as the view.

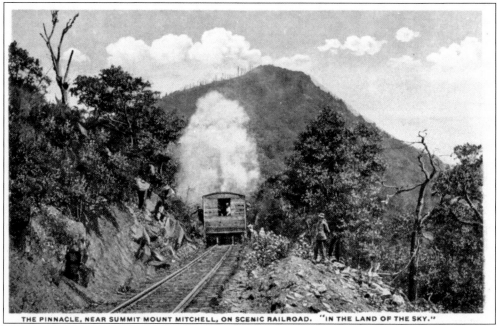

THE PINNACLE, NEAR SUMMIT MOUNT MITCHELL, ON SCENIC RAILROAD. "IN THE LAND OF THE SKY."

This is a view of the Blue Ridge Pinnacle from the Mount Mitchell Scenic Railroad.

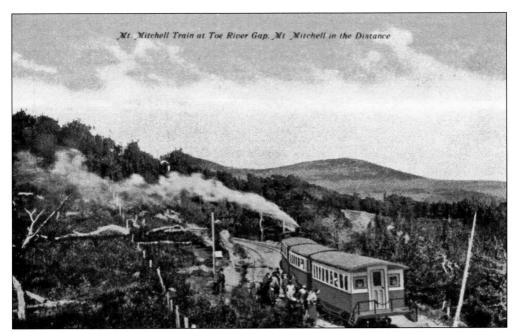

Pictured here are a train stop and the viewpoint at Toe River Gap. A 1918 tourist brochure states, "Top of Eastern North America: Mount Mitchell Railroad, a scenic marvel presenting a peerless panorama of mountain magnificence."

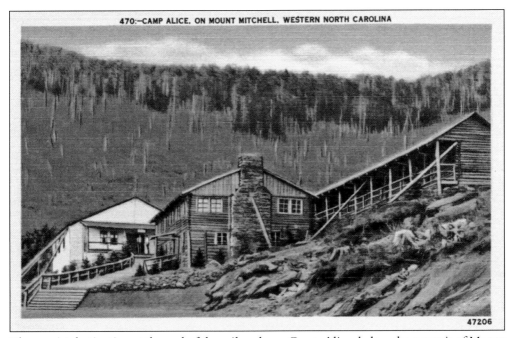

The tourist destination at the end of the railroad was Camp Alice, below the summit of Mount Mitchell. It had a dining room and overnight accommodations. A scenic, but steep, 1-mile trail exists from Camp Alice up to the summit of Mount Mitchell and the observation tower. In 1916, there were 10,000 visitors to Camp Alice.

AUTO ROAD TO MT. MITCHELL, ALTITUDE 6,711 FT., NEAR ASHEVILLE, N. C.—°

"IN THE LAND OF THE SKY"

The tourist railroad ended in 1919 as the railroad concentrated on logging. When logging ceased on August 15, 1921, the Mount Mitchell Development Corporation was formed to again provide tourist access to Mount Mitchell. Several of the same officers of the railroad proposed an auto road over the old rail bed. In September 1921, a condemnation suit was filed against Montreat to allow the auto road on Montreat property.

ON THE SIDE OF "PINNACLE" ON THE WAY TO MT. MITCHELL,

ALTITUDE 6,711 FEET, WESTERN NORTH CAROLINA.

After presentation to the Superior and Supreme Court, it was ruled that Dr. Robert Anderson's contract clause was valid, and the land reverted to Montreat after the railroad usage ended. The Development Corporation was forced to reroute the auto road, bypassing the 6 miles of rail bed within Montreat. Dr. Anderson based his arguments on pollution of the water supply and that it would "expose the institution to the irresponsible public."

ALONG THE MT. MITCHELL MOTOR ROAD, "IN THE LAND OF THE SKY"

The Mount Mitchell Motor Road was completed within one year after logging ceased and officially opened on June 26, 1922. Promotions by Col. Sandford H. Cohen touted the road as "Making the Apex of Appalachia Accessible." In 1923, thirteen-thousand people drove the 19 miles to Camp Alice.

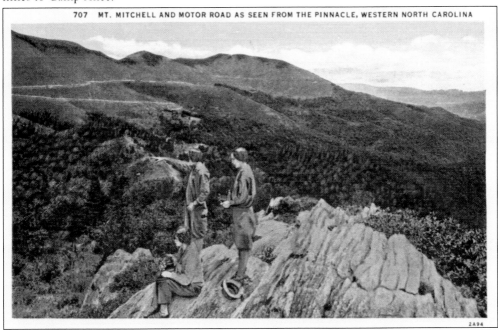

707 MT. MITCHELL AND MOTOR ROAD AS SEEN FROM THE PINNACLE, WESTERN NORTH CAROLINA

The Mount Mitchell Motor Road was one-way up the mountain from 8:00 a.m. until 1:00 p.m., then traffic reversed and cars were allowed down from 3:30 p.m. until 5:30 p.m. Overnight stays were possible at Camp Alice. The fare was $1 per adult and $3 minimum per car. The motor road was used until 1939 or 1940, when the (free) Blue Ridge Parkway was completed to the Mount Mitchell Park entrance.

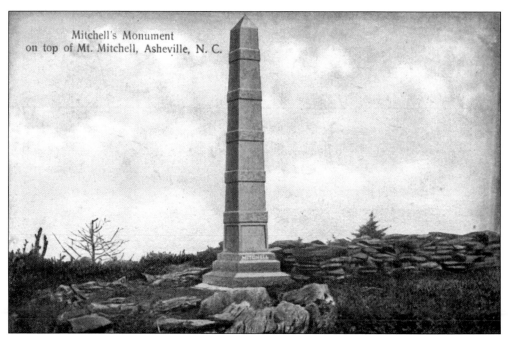

Mitchell's Monument
on top of Mt. Mitchell, Asheville, N. C.

Several monuments have existed to mark Dr. Elisha Mitchell's grave at the summit. This 12-foot, hollow obelisk was made of white bronze and erected in 1888. It stood for 26 years until it was said to have been dynamited on January 4, 1915. Subsequent investigators believed it fell in a windstorm after tourists had been chipping "souvenirs" from the monument for years.

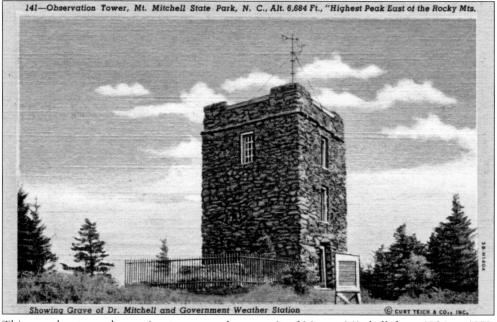

141—Observation Tower, Mt. Mitchell State Park, N. C., Alt. 6,684 Ft., "Highest Peak East of the Rocky Mts.

Showing Grave of Dr. Mitchell and Government Weather Station © CURT TEICH & CO., INC.

This was the stone observation tower on the summit of Mount Mitchell from 1926 to 1959. Earlier viewpoints were ladders or wooden platforms. This tower was replaced first by a concrete tower (1959–2006) and then by a fully accessible tower (2009).

Four

BOARDINGHOUSES
AND HOTELS

Attendance at summer conferences grew rapidly. Improved roads facilitated travel, and by 1932, two-thirds of the southern Presbyterians could reach Montreat in less than a day over hard-surfaced roads. Housing was needed for the thousands that were drawn to Montreat by the mountains, the strong conference programs, and worship services led by the most talented preachers of the day. In 1905, Montreat boasted 14 boardinghouses, and visitors could enjoy the luxurious comfort of the heated Montreat Hotel. In 1907, the Alba Hotel was opened, providing affordable housing for missionaries and ministers. In 1936, the Woman's Auxiliary of the PCUS financed the World Fellowship Hall where women from every country could find lodging. A 1932 advertising brochure states: "Montreat affords all of the best and none of the worst to be had in the mountains." The 1945 letterhead of the Hotel Alba reads, "Montreat is a model Christian community, refreshing to mind, soul, and body. Health conditions perfect." Expressed in the 1930s, the sentiment "Come to Montreat, see its beauties, enjoy its privileges, and you will come again" is still true today.

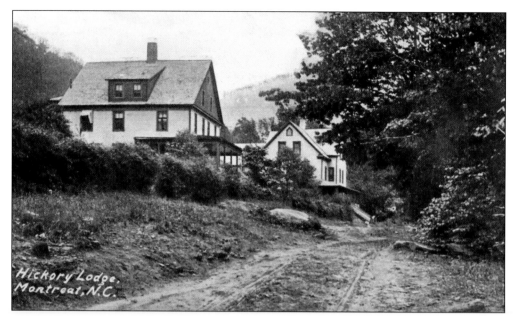

The 1915 conference brochure listed 10 boardinghouses for summer conferees; eight were operated by women. Ellen, Adaline, and Louise Green operated Hickory Lodge (built around 1900) and the Annex, with a capacity of 60, for over 30 years. Arriving in Montreat by 1898, Louise Green was a former teacher at Mount Holyoke College. Contemporaries Dr. Marianna Holbrook and Cora Augusta Stone, retired missionaries from Japan, were members of the Mount Holyoke College Missionary Society.

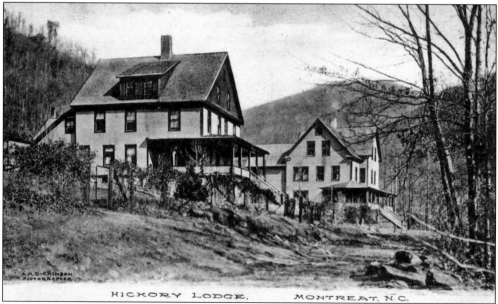

In 1912, two young girls from China attended a conference at the Blue Ridge Assembly and moved to Hickory Lodge for the summer. Each later married a president of China. Ch'ing-ling Soong married Dr. Sun Yat Sen and Mayling Soong married Generalissimo Chiang Kai-Shek. Their father, Charles Soong, was Duke's first international student, a Vanderbilt graduate, and a Methodist missionary before entering the business world and building a fortune.

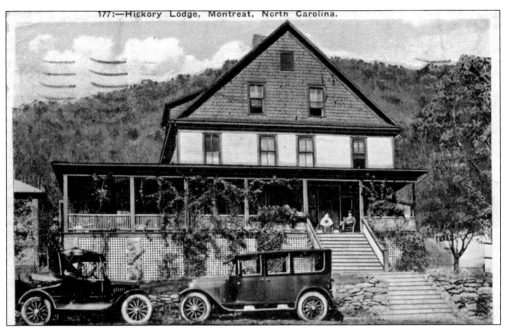

At age 53, musicians Crosby and Juliette Adams "retired" to Montreat from Chicago in 1913. First staying at Hickory Lodge, they built their home, "House-in-the-Woods," at 136 Virginia Road. John S. Van Bergen, a student of Frank Lloyd Wright, designed their home. Personal friends of composers Edward McDowell and Amy Beach, they were recognized worldwide for establishing music education for children in public schools.

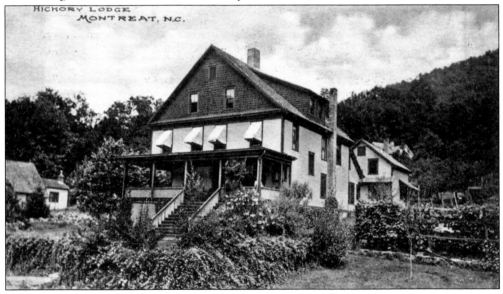

A glimpse of Chinquapin Lodge, one of Montreat's oldest homes, is seen at the far left of Hickory Lodge, shown in the center. Mary Martin purchased a share of Montreat stock for $50, entitling her to select a lot at the "drawing" held on August 31, 1898. Hers was the first name drawn. Acting as Martin's agent, Dr. Marianna Holbrook selected 300 Georgia Terrace as the first surveyed lot to be chosen in Montreat. Chinquapin Lodge was completed by December 1898 and cost $58.71.

Missionary children ("Mish Kids") attending college in the states had no place to go during holidays and summer vacations. Spearheaded by Montreat women, Hickory Lodge was purchased in the 1930s and operated until the late 1950s as the Collegiate Home to provide housing for these "in between times." Gay Currie Fox, now a Black Mountain resident, stayed in Collegiate Home during her days at Agnes Scott College. She was born to missionary parents in China, was a lifelong friend of Ruth Bell, and decorated Gaither Chapel for Ruth's wedding to Billy Graham in 1943.

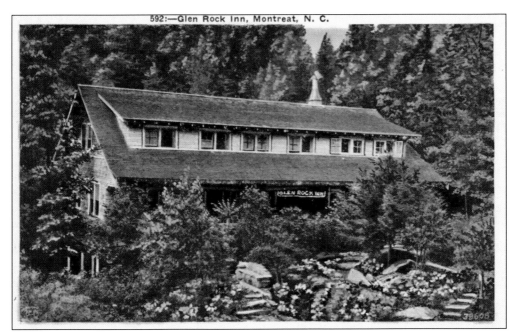

592:—Glen Rock Inn, Montreat, N. C.

The Willie W. McCutchin family of Bishopville, South Carolina, built the Glen Rock Inn in 1907 as a private home. During the Depression of the 1930s, Jane McCutchin began to serve food and take in boarders. Profits were used to run the family farm in South Carolina, which, in turn, provided food for the dining room. In 1944, the C. Thomas Welch family became the owners, continuing the tradition of fine food and comfortable stays. One cannot think of the Glen Rock Inn without memories of southern fried chicken and dessert. Recipes for such Glen Rock Inn indulgences as peach cobbler and fudge cakes and icing can be found in *Inside the Gate*, a 1988 cookbook by the Montreat Scottish Society. The Glen Rock Inn is now owned and operated by the Montreat Conference Center.

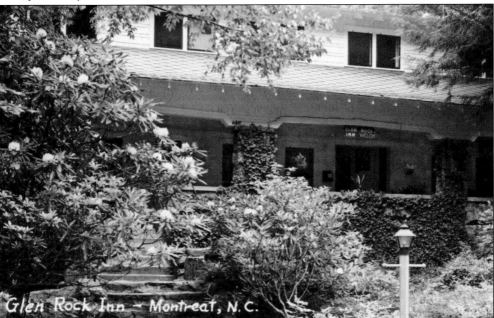

Glen Rock Inn – Montreat, N.C.

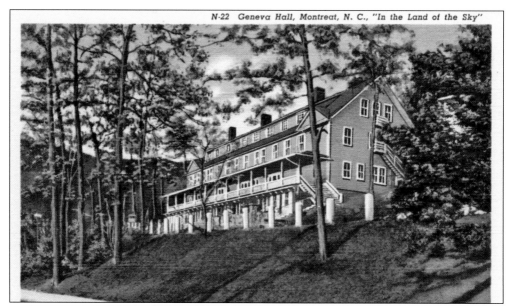

Built in 1913 as the General Assembly's Christian Workers' Home, its name was later changed to Geneva Hall. Funds for the building were raised by members of the managing committee, Robert E. Magill and Charles E. Graham, and the new president, Robert C. Anderson. The Mountain Retreat Association donated two lots. With a capacity for 70, it housed home missionary workers and foreign missionaries on furlough in the states. Later it housed missionary families for 5 to 7 weeks as they prepared for commissioning and departure to foreign fields. Depicted in 1938 and in the early 1950s, Geneva Hall was an imposing structure. It was torn down in the 1970s, well past its prime. Martha Huntley, a missionary to Korea, recounted they were told "if they could stick it out at Geneva Hall for seven weeks, there was no place on earth that they could not handle."

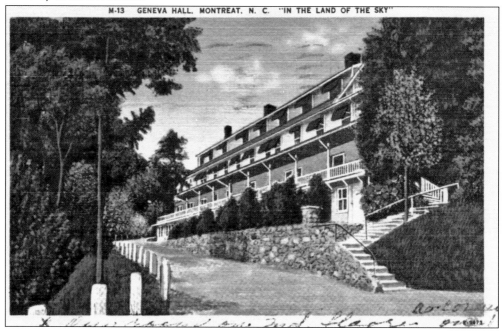

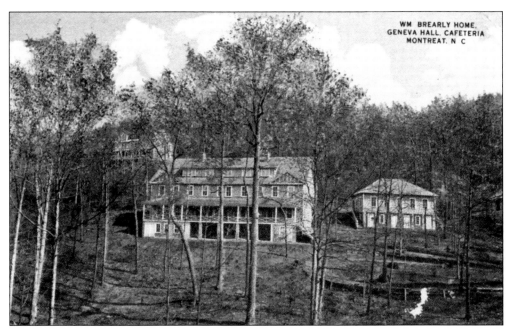

Perched on Brushy Mountain, the William Brearly Home/South Carolina Home is clearly seen in many postcards, but there are no known cards featuring only the 1912 structure. In the card above, the home is seen on the left. Below, it looms over the Lakeside Building. The Mountain Retreat Association donated the lot and McIver Williamson, a wealthy planter from Darlington, South Carolina, gave the building. It was named in honor of his childhood pastor, Rev. William Brearly, who served the Darlington Presbyterian Church from 1842 until 1879. Built as a home for ministers, it is open to all Montreat visitors and is owned by the PCUSA churches of South Carolina. In 1971, the year-round Kirk Apartments were added, named in honor of Amanda Kirkpatrick, hostess of the home for 40 years.

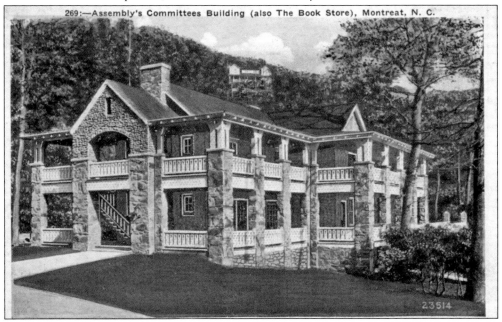

269:—Assembly's Committees Building (also The Book Store), Montreat, N. C.

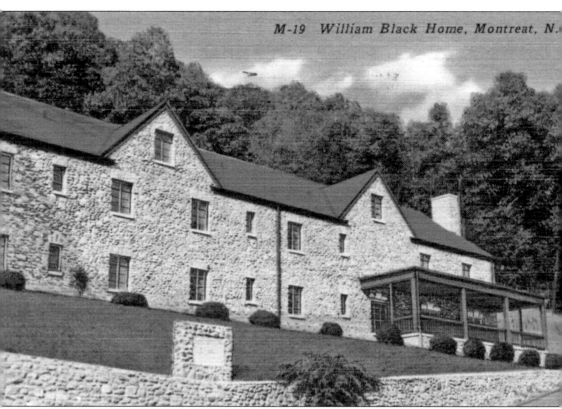

The William Black Lodge, owned by the Synod of North Carolina, was founded in 1915 as the North Carolina Home for Religious Workers in a house purchased from the Charles E. Graham family. In 1912, shortly after approval of the organization by the General Assembly, the Woman's Auxiliary of the Presbyterian Church, U.S., held its organizational meeting in the Graham home (after selling, the Grahams moved to a new home, now the Georgia Lodge, on Assembly Drive). The North Carolina Home was renamed in 1928 for evangelist William Black. It burned in 1946 and was replaced in 1951 with the present stone structure. A portrait of its longtime hostess, Henrietta Copeland, hangs in the dining area. In her hand, she holds the Legion of Merit medal, awarded to her son William Creasy Copeland Jr. He designed an auxiliary hydraulic brake system for the B-24 bomber while serving in Italy during World War II. Henrietta Copeland began as hostess at age 70 and was still making rolls and serving meals at age 89.

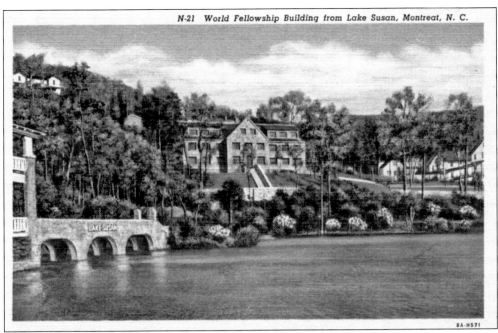

The Woman's Auxiliary gave its entire 1936 Birthday Offering of $31,810 to erect the World Fellowship Building overlooking Lake Susan. At age 73, Dr. Robert Anderson designed and constructed the 40-room stone structure. Reflecting the nature of the 1950s, minorities were able to stay at the appropriately named Fellowship Hall. In the 1970s and 1980s, as the relationship between college and conference center evolved, the building changed ownership and names several times. For several years, it was known as Groseclose Hall. The World Fellowship Hall is now part of the conference center and is known as the Winsborough Building, in honor of Hallie Paxson Winsborough, the first superintendent of the Woman's Auxiliary.

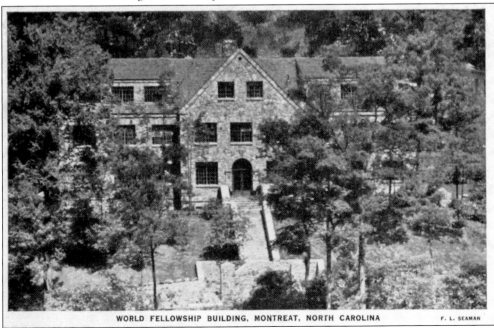

WORLD FELLOWSHIP BUILDING, MONTREAT, NORTH CAROLINA F. L. SEAMAN

69

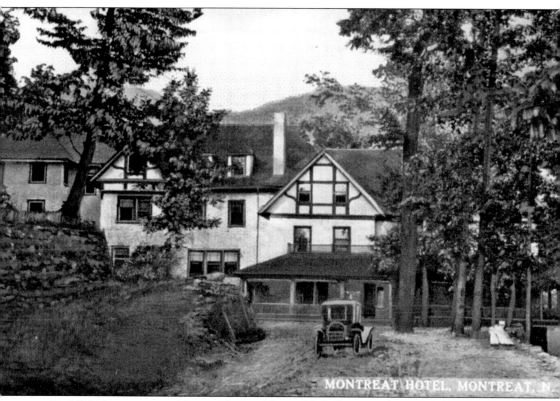

MONTREAT HOTEL, MONTREAT, N.

By 1899, the two-year-old assembly faced financial challenges. John S. Huyler, a Methodist and wealthy philanthropist, accepted the Montreat debt and become its second president (1900–1905) and owner. In 1900, he built the Montreat Hotel for $20,000 to provide comfortable housing. A self-made man, he had developed a high-grade molasses candy while working at his father's bakery and established a chain of confectionery shops that served a special treat, ice cream. According to one account, Huylers was open on Sundays, leading to the custom of ice cream "sundaes" at Huylers. Early in his career, Huyler took Jacob's Pledge from Genesis 28:22, "Of all that thou shalt give me, I will surely give the tenth unto thee." Montreat received the fruits of this pledge. Looking for a buyer for the Montreat property, he offered it to Willis D. Weatherford for use as the YMCA Assembly Grounds. Weatherford declined as Montreat was already quite developed with 30 existing houses on the 4,500-acre tract. In 1906, Huyler sold it to the Presbyterians for $50,000, giving them generous terms. After his death in 1910, his family forgave the outstanding debt.

DRIVE IN FRONT OF MONTREAT HOTEL, MONTREAT, N. C.

The Montreat Hotel could accommodate 124 guests. A heated luxury hotel, it was located on Big Piney Mountain and could be used year-round. In 1915, a room rented for $9–$15 a week. In this same time frame, Montreat's president made $40 a week and his secretary $6 a week. The front of the hotel was oriented towards the entry gate, with the side of the hotel facing the lake. After entering the gate, guests turned onto the Upper Road (Virginia Road) and then continued along the Upper Terrace (North Carolina Terrace), arriving at the drive in front of the Montreat Hotel. In 1916, the hotel became the first home of the Montreat Normal School. The hotel burned on January 21, 1924, while the Andersons were at their winter home in Orlando, Florida. Plans were immediately begun to replace it with the fireproof Assembly Inn.

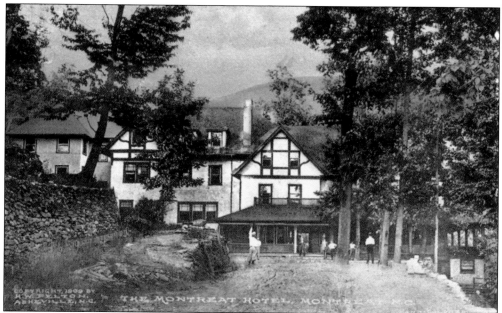

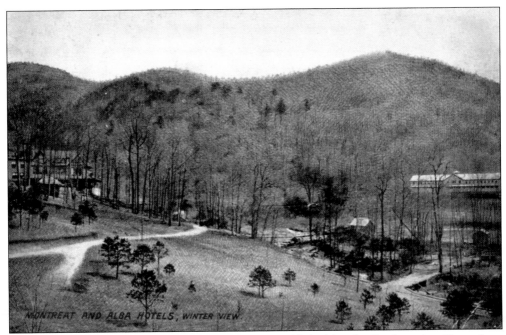

In this 1909 card, manufactured in Germany and published by the Presbyterian Committee of Publication, the Montreat Hotel (left) and the new Alba Hotel (right) face each other. They overlook an almost empty lake, as the leaks in the early wooden dam were not yet fixed. A wooden bridge (lower right) spans Flat Creek connecting the two hotels.

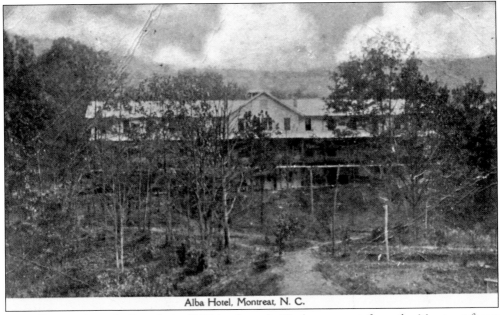

The Alba Hotel was built early in 1907 (as shown). Timber was cut from the Montreat forest and the lumber finished at the sawmill operating near the present site of Anderson Auditorium. It boasted 65 rooms and a dining room for 400, but no lobby, no fireplaces, and no private baths. Porches spanned the front of the building.

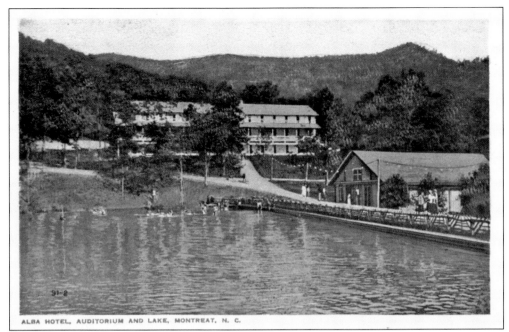

ALBA HOTEL, AUDITORIUM AND LAKE, MONTREAT, N. C.

Christy Huddleston was the Alba's most famous fictional guest. Around 1910, Christy was staying at the Alba and in response to a powerful sermon by Dr. Ferrand (in reality, Dr. Edward Guerrant) she received her call to teach in Appalachia. She returned to the Alba to tell her parents. The 1967 novel *Christy* by Catherine Marshall is the fictionalized account of Marshall's own mother's call to teach in Appalachia.

Catherine Marshall's mother was Leonora Whitaker Wood. According to the 1920 Black Mountain census, Catherine's grandparents George M. and Katherine Whitaker lived on Montreat Road. In the novel, Christy Huddleston was a member of the First Presbyterian Church of Asheville, pictured here (1912 postmark). Two Montreat presidents have been called from this church—Rev. Calvin Grier Davis (1959–1972) and Rev. Albert G. "Pete" Peery Jr. (2008–present).

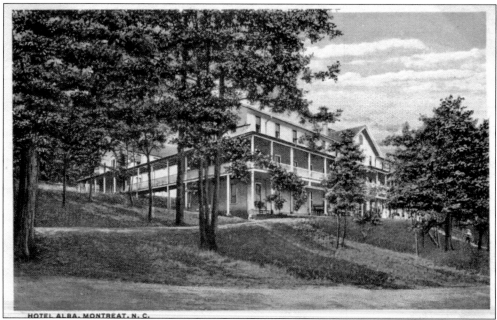

HOTEL ALBA, MONTREAT, N. C.

In 1913, at age 49, Dr. Robert Anderson began his first building project, remodeling the Alba. For $8,000, he added 50 rooms, some with connecting baths; two lobbies with fireplaces; and the building was given a coat of white paint. At a later date, 16 rooms with connecting baths were added. Heat was installed in 1924. The two wings of the remodeled structure were connected by a middle section, which gave the Alba an "H"-shaped configuration. The west-facing wing overlooking the lake had three stories. The east-facing wing looking toward Lookout Mountain had two stories. Some said that the building was so well designed that one could not tell which side was the front, which was the back, and that the middle corridor was frequently used as a "shortcut" up the mountain. (Below, JLSVM.)

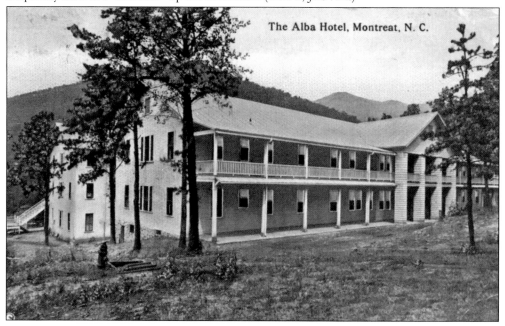

The Alba Hotel, Montreat, N. C.

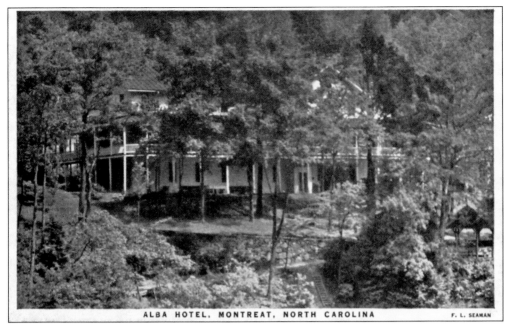

ALBA HOTEL, MONTREAT, NORTH CAROLINA F. L. SEAMAN

The Alba Hotel burned on December 28, 1945. A guest at the Assembly Inn spotted the blaze at 1:00 a.m., and the Black Mountain Fire Department responded. It could not be saved and was gone in five hours. Used as a Montreat College dormitory, it was empty due to the holidays. Two pianos had been sent out for tuning, eight others were burned. The insurance value was $75,000, paid after a full investigation.

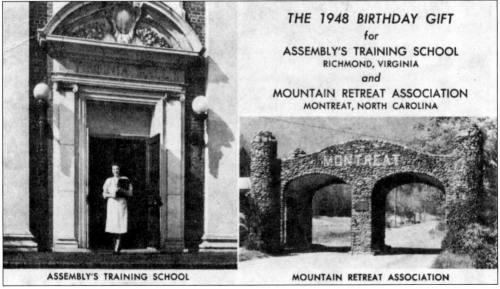

THE 1948 BIRTHDAY GIFT
for
ASSEMBLY'S TRAINING SCHOOL
RICHMOND, VIRGINIA
and
MOUNTAIN RETREAT ASSOCIATION
MONTREAT, NORTH CAROLINA

ASSEMBLY'S TRAINING SCHOOL MOUNTAIN RETREAT ASSOCIATION

In 1948, the Woman's Auxiliary of the Presbyterian Church, U.S., became the Women of the Church, but the Birthday Offerings continued. The 1948 offering totaled $136,732. Approximately $40,000 was given to Montreat to replace the Alba, with the remainder donated to the Presbyterian Assembly's Training School in Richmond, Virginia. Montreat has been the recipient of four Birthday Offerings: Montreat Gate (1922), World Fellowship Hall (1936), Collegiate Home (1941), and Howerton Hall (1948).

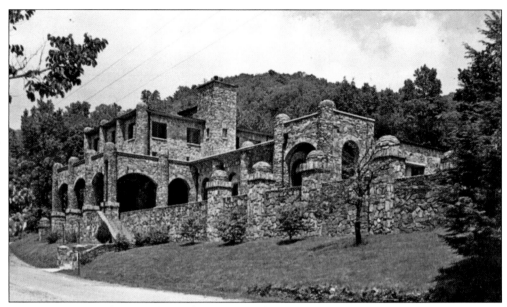

At age 82, Dr. Robert Anderson began plans for the new Alba. He designed an imposing structure to be built by local craftsmen using rock from the Montreat mountains. It was to have two wings each three stories high. A long one-story connector, with dining facilities for 800, would bridge the two wings, which would, in turn, frame Gaither Hall, long hidden by the old Alba. Though ready for the 1948 conference season, the new Alba was never fully completed as designed; the southern wing was never built. At age 83, Dr. Anderson resigned as president of the Mountain Retreat Association on December 31, 1946, and from all college and other responsibilities on July 31, 1947. He retired to his home in Orlando, Florida. The new building was named Howerton Hall, honoring Rev. James R. Howerton, who conceived and implemented the 1906 Presbyterian purchase.

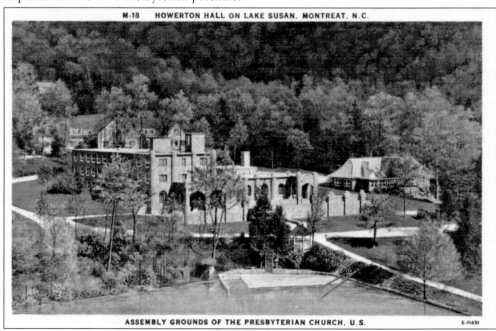

M-18 HOWERTON HALL ON LAKE SUSAN. MONTREAT. N.C.

ASSEMBLY GROUNDS OF THE PRESBYTERIAN CHURCH, U.S. E-11451

Five

ASSEMBLY INN AND PRESBYTERIAN HERITAGE

The Presbyterian Church is organized into four hierarchical levels—the local church; a presbytery (a group of churches); a synod (a group of presbyteries); and the General Assembly (all synods). Presbyterians govern the church through a representative form of church government with elected delegates attending annual (present-day biennial) meetings of the General Assembly to determine church polity. It is helpful to have this knowledge to understand the relationship the Presbyterian Assembly Grounds has with the Presbyterian Church.

The Mountain Retreat Association was originally financed in 1897 by selling shares of stock to individuals, largely from the North, entitling them to select a lot in the new community. The original venture fell into financial distress and was sold to southern Presbyterians, who again financed their purchase by selling shares of stock and entitling stock owners to select a lot. These shares were purchased largely by individual southern Presbyterians, not by the church itself. In 1906, the Synod of North Carolina and in 1907, the General Assembly each endorsed the purchase in concept but had no financial stake in the assembly grounds. In 1916, a plan was implemented in which many shareholders returned their stock shares, but not their property, back to the Mountain Retreat Association. The unsold property and buildings were placed in the hands of the trustees to be held and used for the church but were not actually owned by the church. In 1923, Montreat became the official conference center for the Presbyterian Church (US), and the first of 24 meetings of the General Assembly took place there. Ministers bought homes here. Missionaries came on furlough and returned to make Montreat their permanent residence after leaving the mission field. In 1927, the Presbyterian Historical Society moved its location from Texarkana, Texas, to Montreat. Today the rich heritage of Montreat and the Presbyterian Church is maintained by the Presbyterian Heritage Center at Montreat.

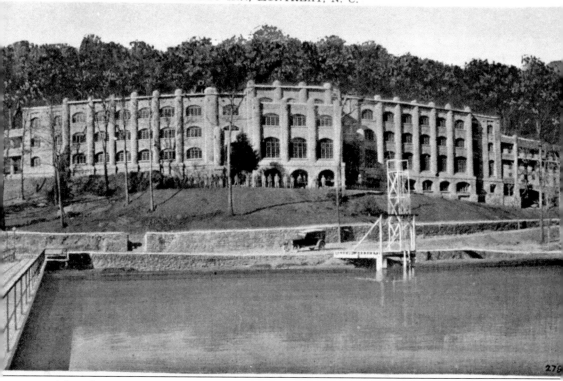

After the 1924 Montreat Hotel fire, the Montreat Managing Committee and Dr. Robert Anderson, at age 60, immediately began plans for a fireproof hotel on the site. This time the front entrance would overlook Lake Susan. The Assembly Inn was completed five years later after a difficult fund-raising campaign. Hallie Winsborough, superintendent of the Woman's Auxiliary, put out a plea: "Montreat is the real, live, throbbing heart of the southern Presbyterian Church. Can You Help?" The first meal in the dining room was served in the summer of 1928 to the Woman's Advisory Committee. In May 1929, the inn was fully opened and hosted delegates to the General Assembly. Early arrivals helped workmen arrange the furniture and clean the construction debris. The women of Montreat made the beds and set tables. Looking carefully at this card, postmarked 1929, one can see a group gathered in front of the hotel, but one can only conjecture who they might be. Perhaps they were newly arrived commissioners. Or for those with long ties to Montreat, perhaps even ancestors.

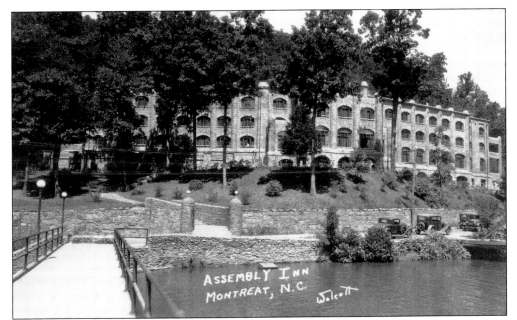

In 1933, Assembly Drive and the roadway around the lake were paved (one and one-quarter miles). Idled by the Depression, the North Carolina State Highway Department provided the men and machinery. Montreat paid for the labor and materials.

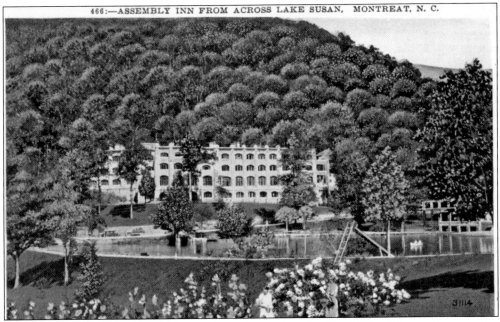

The Assembly Inn was open to the public and was advertised in 1932 as "the perfect stopping place for those traveling between the South and the North," with 10 trains a day arriving at the Black Mountain Station. Transportation to Montreat was 50¢ and trunks, 75¢. Rooms rented for $40 a week on the American plan, and the management reserved the right to put anyone into a double room.

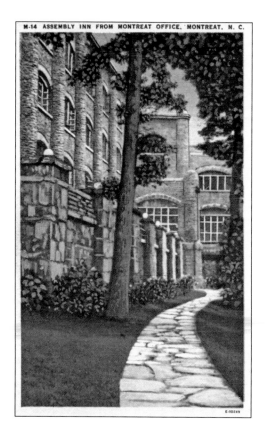

The Assembly Inn is one of Montreat's most beautiful buildings. It is built of rock rounded by the rushing waters of Montreat streams. When asked why he did not build of brick, Dr. Anderson answered, "We could get better results for less cost." The inn was built by local workmen under the direction of construction supervisor Herman Holdway. When the supply of stone became low, the problem was easily solved. The valves on the dam were opened, and the rushing waters exposed more rocks. With an ever-plentiful supply, the building continued. One of the stonemasons, William (Rip) H. Cordell Sr., was 11 years old when Montreat Presbyterian Church was founded in 1906. His son William H. Cordell Jr. is a member of the Black Mountain Presbyterian Church.

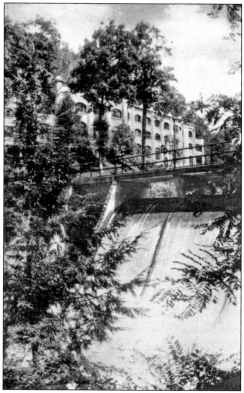

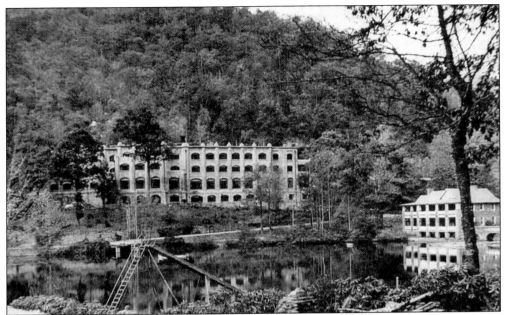

Construction began with only the $12,000 Montreat Hotel fire insurance money in hand. The final cost was $225,000 with an additional $75,000 for the furnishings. Fifty-five carloads of cement were used in the construction of this imposing structure. Reinforcing steel came from the Dave Steel Company in Asheville, and the forms were built from Montreat lumber. When finished, the inn boasted 130 rooms, a barbershop, a beauty parlor, a large lobby with a fireplace, dining room, kitchen, telegraph office, and seven porches. The elevator was not added until 1938. The luxury four-story inn was entirely fireproof with only the doors made of wood. No fire insurance was carried on the structure. In 1929, the *Charlotte Observer* called the inn "the pride of the Presbyterians, sitting above Lake Susan, where ministers and layman dip and play."

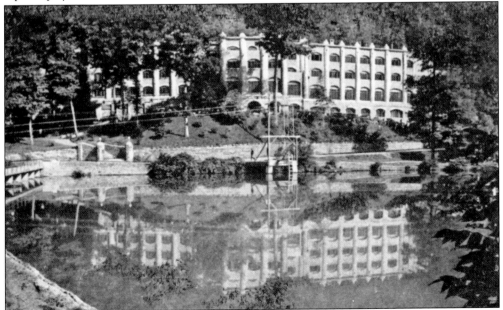

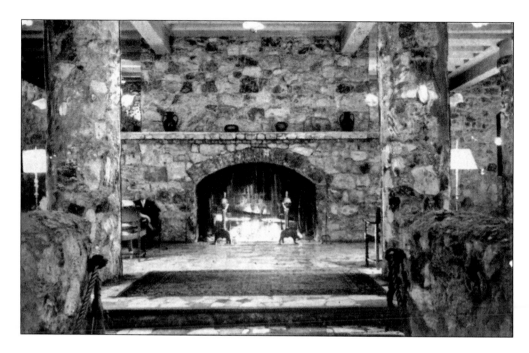

Quite different from today, the access from the ground-floor entry to the lobby in 1929 was by a grand staircase directly in the center of the lobby. As one climbed the staircase, the imposing 5-foot fireplace and mantle came into view. The andirons were given by the Mattox Foundry of Archer, Florida, and are still in use. The interior walls were built of stone from the Montreat grounds and sparkled with quartz and mica. A 1932 travel article in the *Charlotte Observer* found it the most unique hotel in America and marveled at the "Rainbow Hotel . . . where guests are expected to attend religious services, and be awake when the collection basket comes along."

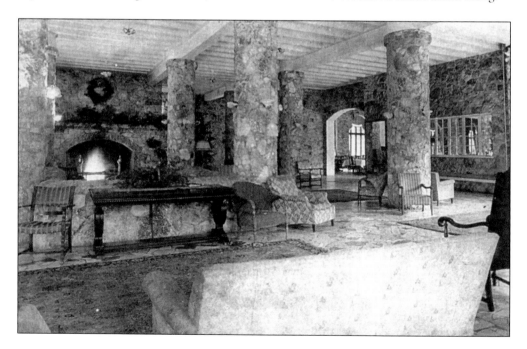

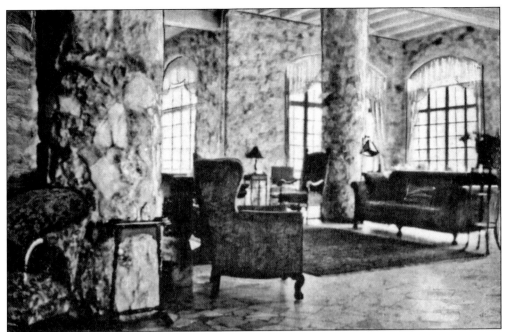

The furnishings in the lobby and rooms were donated by individuals and churches. A guest room could be furnished for $350 and a bronze memorial plaque placed on the door. Plumbing and electrical systems were embedded inside the round stone columns supporting the inn. The seashell lighting fixtures attached to the pillars were most unusual in a mountain hotel. The conch shells came from Florida and the pearl snail shells from the Indian Ocean. According to Dr. Anderson, "While God was making in the mountains the color in the stone, He was making in the sea the color of the shells." The original tables in the Galax Dining Room were built on-site, in the hotel lobby. The dining hour was announced by the sound of a gong, and the meal served. (Note the waiter by front left column.)

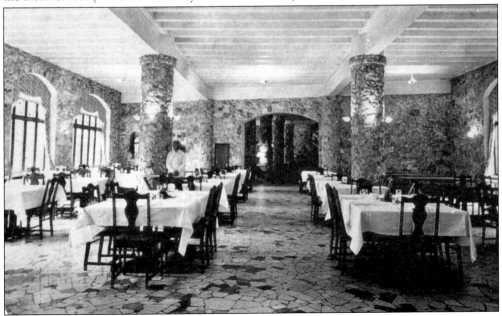

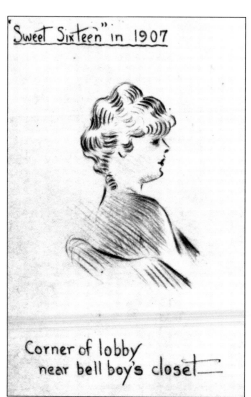

"Sweet Sixteen" in 1907

Corner of lobby
near bell boy's closet

Among the most unique cards in the book, the information on the back reads: "This is one of the many faces and figures of people and animals which can be seen looking out from the marble floors, stone walls, and pillars of the lobby and dining room, Assembly Inn, Montreat, North Carolina. Some were unintentionally formed by the builders through combinations of stones and mortar, while others are complete in one stone just as broken open at the quarry. Perhaps in no case did the stone mason see these figures before the stones were placed—truly a marvelous array!"

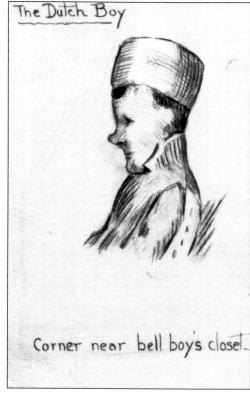

The Dutch Boy

Corner near bell boy's closet

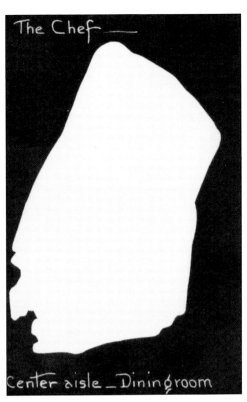

The Chef —

Center aisle _ Diningroom

One of the oft-told stories of Montreat is that of the marble floors in the dining room and lobbies. These beautiful floors, upon which many Montreat saints have trod, are made of scrap marble donated by several marble yards from Knoxville, Tennessee. The face of "The Clown" was located on the lobby floor to the left of the main stairway, but it may have been destroyed during the renovations of the 1960s. "The Chef," however, located in the center aisle of the Galax Dining Room, is quite possibly still there, but as of yet undiscovered.

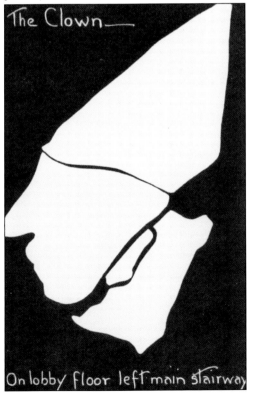

The Clown —

On lobby floor left main stairway

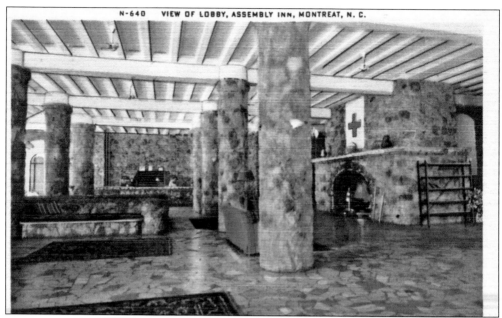

The registration desk was to the left of the grand staircase. A Red Cross banner hangs over the fireplace, and a five-tiered rack stands beside the chimney, ready to hold a gentleman's fedora hat. In 1943, Claudia McGraw managed the dining room. A Black Mountain native, she was widely known as the "Apron Lady," famous for her meticulously designed and double-stitched aprons. McGraw's aprons have been featured in *Southern Living* magazine and were sold in New York boutiques as well as directly from her own home, the present site of the Black Mountain Bistro. Greta Garbo owned several of McGraw's aprons. Claudia McGraw was the dining room hostess for the wedding reception of Billy Graham and Ruth Bell Graham, held at the Assembly Inn on August 13, 1943.

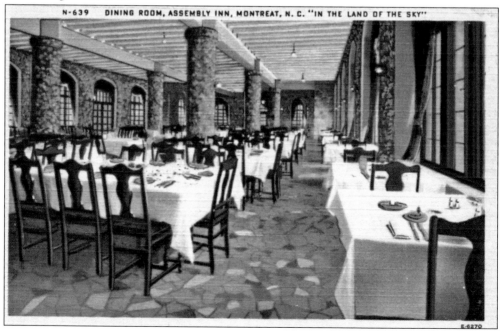

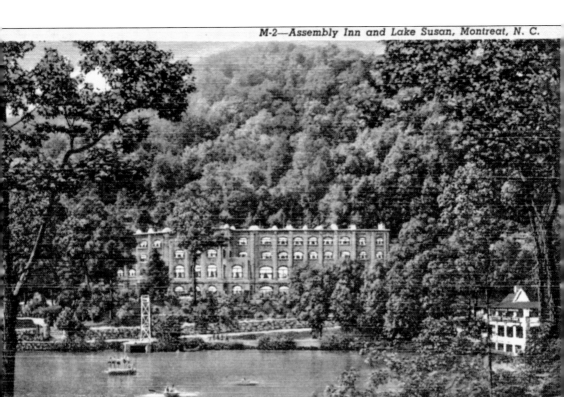

CURT TEICH & CO., INC. OB-H2397

One of the most interesting episodes in the inn's history took place between October 29, 1942, and April 30, 1943. The U.S. government housed 264 German and Japanese diplomats and their families in the inn as they awaited exchange for American diplomatic and missionary families in Axis countries, each group caught behind "enemy lines" when World War II broke out. Their movement was restricted to the inn and the area in front of Lake Susan. They were accompanied by one State Department official and 25 guards. The German men were allowed to stay with their families. The Japanese men were sent to an internment camp in Texas. Teachers at Montreat College were pressed into serving the meals. Bibles, in the appropriate language, were placed in each room. Young people from nearby Black Mountain caroled outside of the inn for Christmas in 1942, singing "Joy to the World" and "Silent Night" along with the internees. Montreat made a $75,000 profit during the six-month internment period; $25,000 was set aside for a building to house the Presbyterian Historical Foundation.

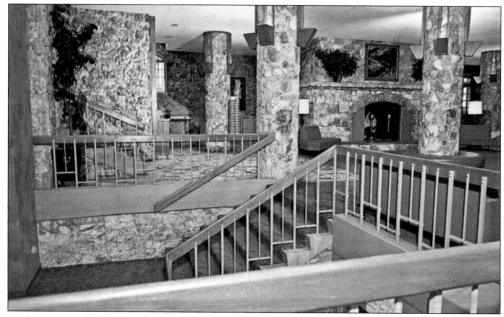

In the 1960s, the inn was remodeled for $800,000 under the leadership of Pres. Calvin Grier Davis. The center stairwell was relocated to its present position on the left side of the lobby. The fireplace was reconfigured and reduced in size and a hearth added. The picture over the fireplace still hangs in the lobby, but at another location. A dropped ceiling was added and the seashell lights were replaced with "birdhouse" fixtures. The guest rooms were also refurbished. In the 1960s, the cost to furnish a room and have a second bronze memorial plaque placed on the door was $2,500. Much of the heritage of the southern Presbyterian Church is recorded on these doors, seen and felt as one walks its halls. In a later renovation, the registration desk was moved to the ground floor.

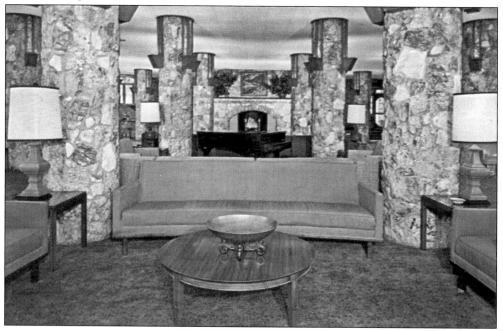

The Wharton porch, overlooking Lake Susan, was added during the 1960s.

The small log cabin, built by Anderson Kelly in the late 1880s as his home, and the site of the Montreat Office for over 50 years, was torn down to make way for the Jennie Richmond Armstrong Convocation Hall. The hall, with a seating capacity of 200, was completed around 1968.

A CORNER OF THE VAULT, HISTORICAL FOUNDATION,
MONTREAT, NORTH CAROLINA

In 1902, Dr. Samuel Mills Tenney found the theology notes taken in 1845 by Robert Lewis Dabney during his senior year at Hampden-Sydney Seminary. They were in a Texas bookstore, bound and about to be discarded. Reverend Dabney was a leading figure of the church in the 1800s and a founder of the forerunner of Austin Theological Seminary. Dr. Tenney, recognizing that the history of the church was being lost, began collecting church records. By 1926, the collection was officially established as the Historical Foundation of the Presbyterian and Reformed Churches, but it had already outgrown its location in a room of the First Texarkana (Texas) Bank. In 1927, Dr. Robert Anderson offered two rooms on the ground floor of the Assembly Inn free of charge. The library and museum occupied 1,000 square feet in the inn for 27 years.

LIBRARY AND MUSEUM, HISTORICAL FOUNDATION,
MONTREAT, NORTH CAROLINA

The Historical Foundation printed a number of postcards, many of them photographed by Ed DuPuy of Black Mountain. Often they showcased items held by the foundation such as this bust of Rev. James Stacy, the first stated clerk of the Synod of Georgia. Other times they might simply send out a New Year's wish along with their own 1948 hope for a new home—a dream realized six years later. (Below, RN.)

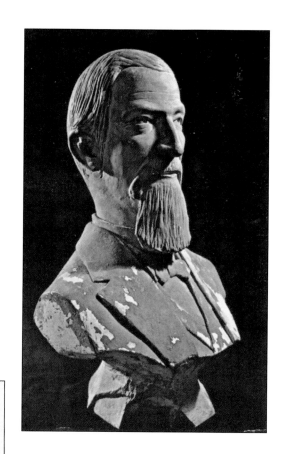

New Year's Wish

(Illustrated)

This little card
 is sent to you
From our familiar
 rendezvous:

To wish you all of happiness
The year can bring, and to confess
A fervent hope, ere it be done,
To have the home below begun:

The Historical Foundation
Montreat, North Carolina
December 27, 1948

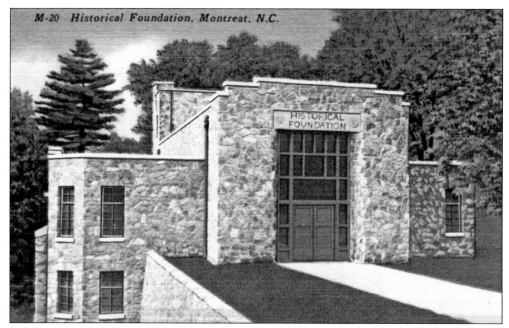

In 1954, the Historical Foundation moved to its new location in Spence Hall. It was named for Dr. Thomas Spence, director from 1939 to 1969. This new building was not made of Montreat stone. In the early 1950s, a new road was being built over the steep grade from Old Fort to Black Mountain (the present Interstate 40). The broad-faced rocks of Spence Hall were obtained at a very good cost from this road project.

Representing many, Helen La Bonte sits at the desk of the Local Church History Program, eager and ready to serve. The Historical Foundation became a branch of the Presbyterian Historical Society, headquartered in Philadelphia, when the Presbyterian Church, U.S., and the United Presbyterian Church, U.S.A., reunited in 1983. In 2006, the Montreat branch was closed. On May 24, 2008, the Presbyterian Heritage Center at Montreat located in Spence Hall was opened to maintain a historical presence in Montreat.

Six

CONFERENCE, COLLEGE, AND CAMP

The Montreat Conference Center is one of three designated conference centers of the Presbyterian Church (USA). More than 35,000 attend retreats and conferences each year with the conference center following its mission of "Strengthening Churches, Building Relationships, and Growing Disciples."

Montreat College was incorporated in 1916 as the Montreat Normal School. The college is now a four-year coeducational institution with 462 traditional students and a total enrollment of 1,100. Its motto is, "Christ Centered—Student Focused—Service Driven." Until 1975, the conference center and the college had the same person as president. Buildings of each institution were used interchangeably for conference activities during the summer and college activities during the winter. The conference center and college now operate independently, each having its own president and its own governing body. In broad terms, Montreat College buildings are on the east side of Lake Susan with the conference center to the west and above and below the lake.

Camp Montreat for Girls was located on 28 acres near Lookout Road and was privately owned by Robert C. Anderson and William Henry Belk. It was in operation from 1925 through 1967, with proceeds from the camp funding college activities. The camp property was donated to the college on May 15, 1946. The stories of the conference center, the college, and the camp are all enfolded into one as they shared presidents, facilities, and campuses for almost 60 years.

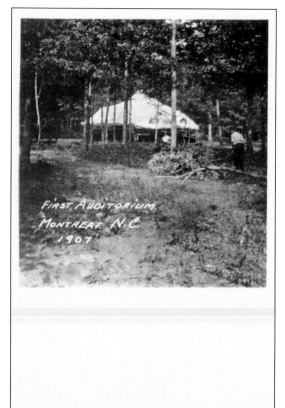

On July 20, 1897, four hundred gathered for the first Christian Assembly (present site of Montreat College). Rev. Francis M. Lamb of Salem, Massachusetts, preached the Word. Mr. L. W. Brown of New York City, recently saved from sin, led the singing. Fanny Crosby's hymn, "Saved by Grace," was sung repeatedly. In 1907, the Presbyterians worshiped in this tent auditorium. (PHC.)

Tents were pitched to house the conferees, and a dining tent and kitchen area were set up (on the present site of Montreat College). Kitchen Branch and Puncheon Branch flowing down Brushy Mountain supplied water needs. Tents rented for $1.25 a week, and meals were $4 a week. The Presbyterians eventually moved their assemblies and tents down the mountain, near the ball field on Assembly Drive. In 1964, the present campground was built off Calvin Trail.

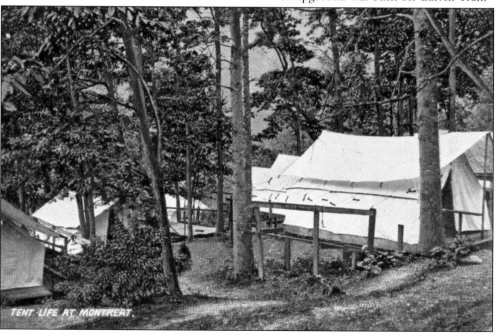

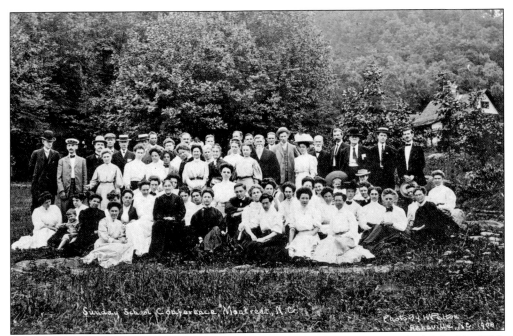

Real-photo postcards were popular souvenirs in the early 1900s. Postmarked July 30, 1908, this card pictures Sunday school conference attendees gathered near the ball field on Assembly Drive. The handwritten message reads, "If you care for more of these postals they may be had from us at $1.00 per Doz. Sincerely, H. W. Pelton." (RN.)

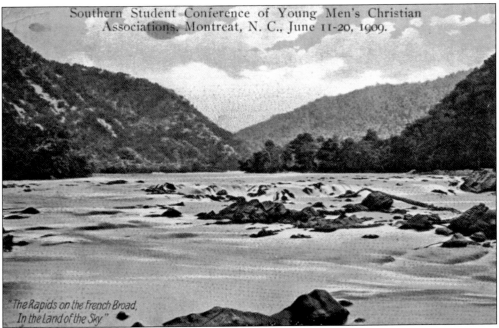

Montreat was founded as interdenominational assembly grounds. After the Presbyterian purchase, it continued to be open to other groups as well. The YMCA held its summer conferences in Montreat until the Robert E. Lee Hall at Blue Ridge Assembly was completed in 1912.

Calvin Auditorium, seating 1,200, was constructed around 1908. In 1915, Dr. Walter L. Lingle (president of Davidson College, 1924–1941) was chairman of the Program Committee. The conference season ran from July 4 to August 26. Rev. J. Wilbur Chapman led the conference on evangelism, and the North Carolina Forestry Association held its annual meeting here, discussing Mount Mitchell logging. Montreat also sponsored an address on "What the Bible teaches about Conservation."

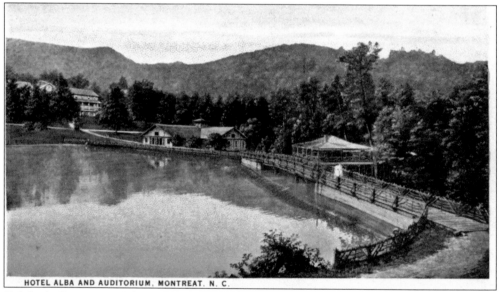

HOTEL ALBA AND AUDITORIUM, MONTREAT, N. C.

Calvin Auditorium and the bookstore (foreground) were built along the dam. The auditorium had a tin roof with the rain often drowning out the speaker's voice. Both buildings survived the 1916 flood but appear to have been torn down in the 1920s. Susan Graham, the donor of the dam, stipulated that no building was to ever again be constructed along the dam. This did not prove to be the case.

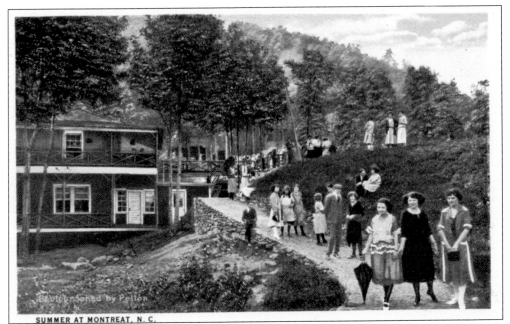

Summer visitors enjoyed the lake and the bookstore. In the early 1900s, they followed much the same path one follows today from the top of the dam to the lower levels. In 1923, William Henry Belk donated a playground near the foot of the dam. He was the founder of Belk Department stores and a Montreat trustee for 45 years (1907–1952). Today children still play in the waters of the stream below the dam. (RN.)

Built in 1926, the Prayer Room was a small frame structure. Construction was authorized in 1919, but it took Eliza Murphy seven years to raise the necessary $700, much of it in dollar donations. A young Ernest Arnold of Montreat made the sign. Here Mrs. Jose Reyes, wife of the Spanish professor, visits with two students. Torn down to make room for the Belk Campus Center, the Prayer Room was replaced with the Prayer Porch, dedicated on August 25, 1986.

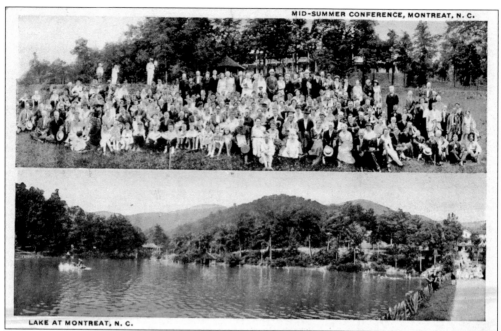

LAKE AT MONTREAT, N. C.

A group of mid-summer conferees gather in front of the Alba Hotel around 1920, posing by the lake (above). In the card below, postmarked 1929, a group of women make their way to and from the Alba. The first Women's Conference was officially held in 1911 and for decades was the highlight of the summer conference season. Attendance during the 1950s often topped more than 1,000. Some years, a banquet was held to celebrate the Birthday Offering. The recipient of the coming year's Birthday Offering was a well-guarded secret until the banquet. Adding to the excitement, the winner of the highly competitive "state by state" competition to donate the highest offering was also announced. Over the years, the conference name has changed to reflect its focus. Once called the Women's Training School, then the Women's Conference, today it is called the Women's Connection.

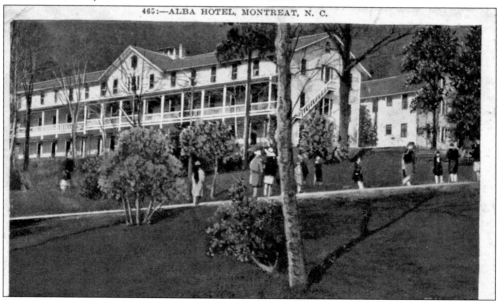

465:—ALBA HOTEL, MONTREAT, N. C.

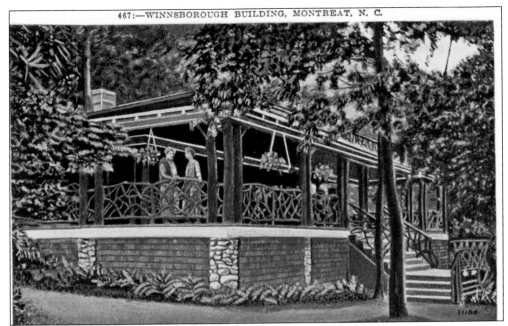

The Women's Building, completed in 1916, was the social and business hub of the women's activities. Known as the Winsborough Building, it was named after Hallie Paxson Winsborough, the first superintendent of the Woman's Auxiliary. The building housed office space and a library but is best known for its large porch with rhododendron balustrades and its location beside a bubbling stream, the perfect spot for socializing and courting.

After 40 years, time took its toll on the Women's Building. It was replaced around 1960 with this structure. In the early 1980s, this was also torn down. The new William Henry Belk Campus Center was built on the site and dedicated on October 24, 1985. The World Fellowship Hall was remodeled and renamed the Winsborough Building to preserve the historical role of the women in Montreat and the memory of Hallie Paxson Winsborough.

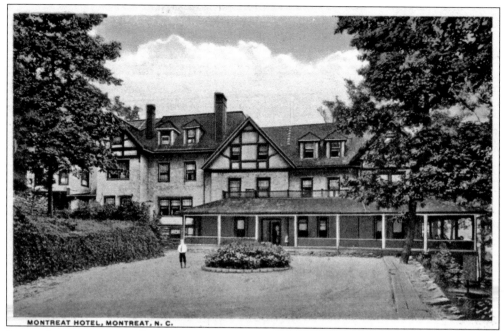

MONTREAT HOTEL, MONTREAT, N. C.

It soon became apparent that summer conferences alone could not support the infrastructure. The Montreat Hotel was heated, making it suitable for year-round use. The Montreat Normal School for Girls, dedicated to training teachers, opened in the hotel in 1916 with eight students. By the summer of 1917, twenty-five had enrolled. The hotel burned on Friday, January 21, 1924, while the Andersons were at their winter home in Orlando, Florida.

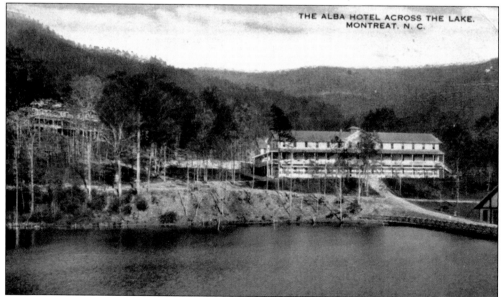

THE ALBA HOTEL ACROSS THE LAKE. MONTREAT, N. C.

Heat was installed in the Alba Hotel in 1924. It was used as a dormitory and for conference housing until it burned on Friday, December 28, 1945. Billie Gregory, the founder of Black Mountain Sunshine School Kindergarten (1946–1976), was a student at Montreat College in the early 1930s, having first visited Montreat with her Aunt Lulu, a delegate to the 1931 Women's Conference.

100

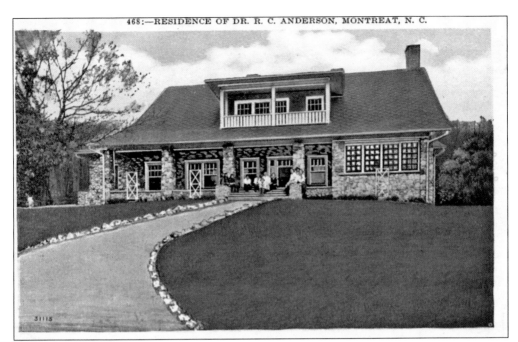

The residence of Dr. Robert C. and Sadie Gaither Anderson was called "Montozone," or "Mountain Air." Built in 1912 as a wooden structure, the stone facing was added at a later date. Standing at 370 Florida Avenue, it is the current family home of the president of Montreat College. Here Robert and Sadie Anderson sit on the steps with girls from the Normal School.

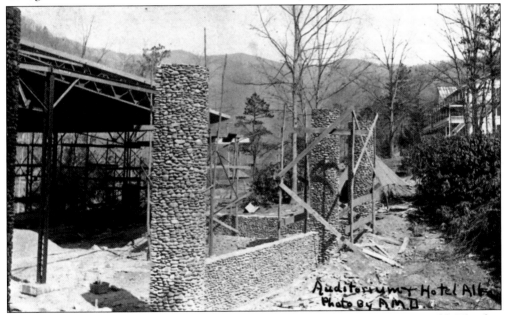

Anderson Auditorium was completed in 1922 when Dr. Anderson was 58 years old. The first major building project of the Anderson years, construction was begun around 1920, and the building material was the most plentiful and easily available. It was built of stone collected from Montreat streams. Round columns support the roof as they were found to be two-thirds cheaper to construct than square columns. Local workmen built the auditorium. (PHC.)

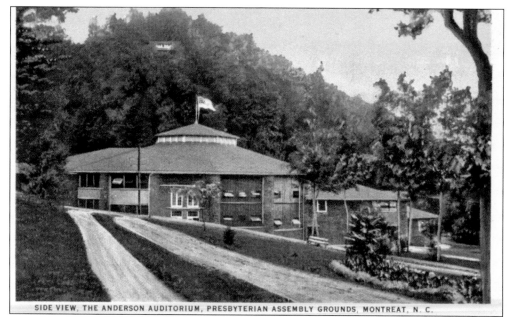

SIDE VIEW, THE ANDERSON AUDITORIUM, PRESBYTERIAN ASSEMBLY GROUNDS, MONTREAT, N. C.

On July 11, 1921, the *Asheville Citizen* newspaper reported, "Montreat Auditorium costing about $100,000 is nearing completion . . . All construction work has been by day labor, under the personal supervision of Rev. Anderson. No contractor was engaged. In this way it is believed a considerable sum was saved. Architects Smith and Carrier of Asheville designed the building." Richard Sharp Smith was the architect of the Biltmore estate and the 1921 Black Mountain firehouse.

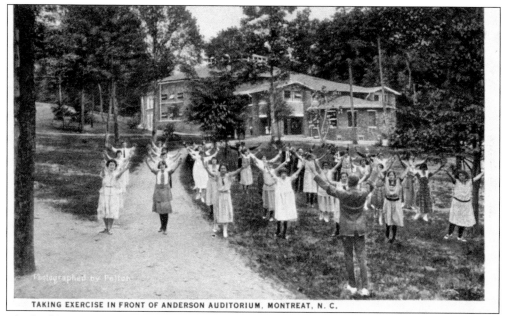

TAKING EXERCISE IN FRONT OF ANDERSON AUDITORIUM, MONTREAT, N. C.

The building contained classrooms, a chapel, and a large auditorium seating 3,000. Built in the shape of an octagon, but with 16 sections instead of eight, it had four entrance halls and 12 double doors to accommodate large crowds. The pews had hickory frames and split-oak backs and bottoms. Cheaper than manufactured pews, they were also less comfortable.

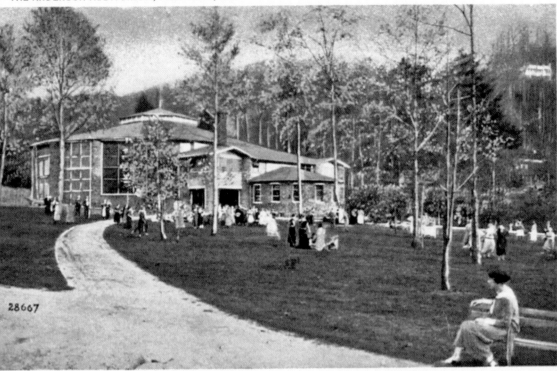

28667

In September 1922, classrooms were transferred from the old Montreat Hotel to the new Anderson Auditorium, and the students enjoyed the beautiful grounds outside the auditorium. The Montreat Presbyterian Church worshiped in the chapel from 1922 until 1936. During the summer months, worship was held in the main auditorium. At age 27, Peter Marshall delivered a 1929 sermon to the young people at the conference center denouncing the evils of drinking and smoking. Peter married Catherine Marshall in 1936 and served as the chaplain to the U.S. Senate for two years in the late 1940s. Writings by Catherine Marshall include *Christy* and *A Man Called Peter.* Anderson Auditorium burned on Monday, April 1, 1940, its asbestos roof exploding. The cause of the fire was attributed to combustible material left behind after a play the previous night.

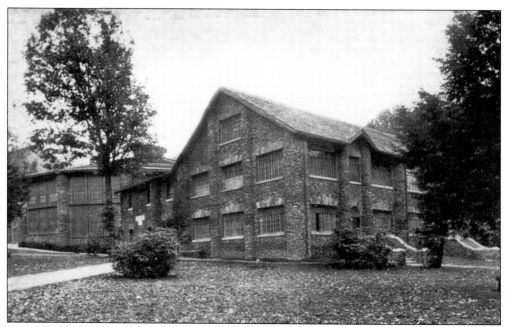

After the fire, Dr. Anderson, at age 76, and the local workman immediately started to rebuild. The "new" Anderson Auditorium was ready for the conference season on June 28, 1940. The "new" Anderson Auditorium was much the same as the "old" but with a smaller rotunda and pews made of chestnut. In later remodeling programs, heat was added, the acoustics improved, and the front porch added.

This group from Texas and Oklahoma was photographed on the front steps of the new Anderson Auditorium on July 27, 1940, only one month after it was rebuilt and only four months after it burned. (PHC.)

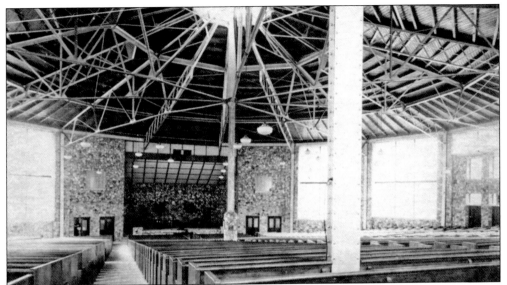

Lives have been changed in Anderson Auditorium. From the mid-1930s to the 1970s, missionaries to foreign fields were commissioned here. For more than 50 years, musicians have met here to attend the Worship and Music Conference. In the summer of 2008, more than 6,000 high school students attended youth conferences. Each year, graduating students from Montreat College receive their diplomas as they cross the stage of Anderson Auditorium.

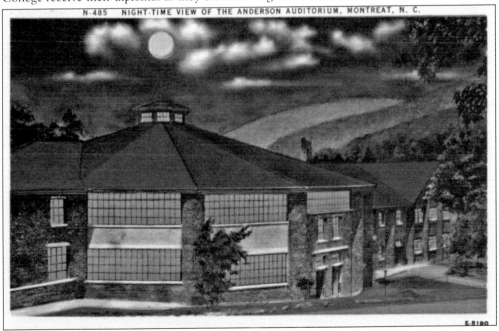

Campers, residents, visitors, and conferees worship together on Sunday mornings in Anderson Auditorium. In the early 1950s, a young Billy Graham, a Montreat resident, shared his message from the Anderson Auditorium pulpit. On August 4, 2000, four governors of North Carolina, Bob Scott (1969–1973), Jim Holshouser (1973–1977), James Martin (1985–1993), and James Hunt (1977–1985, 1993–2001), each a Presbyterian, took part in a panel discussion on "Faith and Vocation" with a full house of Presbyterians in attendance.

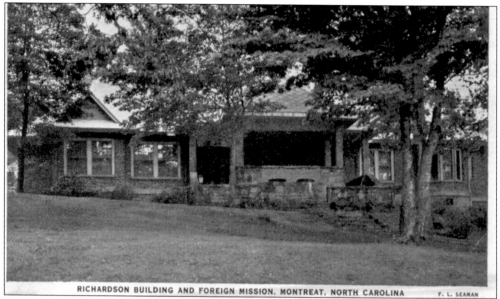

RICHARDSON BUILDING AND FOREIGN MISSION, MONTREAT, NORTH CAROLINA F. L. SEAMAN

Built in 1923, this was the summer meeting place of the Presbyterian Committee on Foreign Missions. Funds were donated by Mary Lynn Richardson whose husband, Lunsford, was a pharmacist and had formulated Vicks VapoRub. Originally designed as a frame structure, it was built of stone and the roofline given a slight oriental flair. It has been known as the Foreign Mission Building, the Richardson Building, and more recently as the Way Out Building. For years, it was home to the Institute for Foreign Mission, where missionaries trained before being commissioned and departing immediately for Brazil, Congo, China, Korea, Japan, or Mexico. It was quite literally the "way out." In 1961, at its peak, 43 missionaries studied here and were commissioned in Anderson Auditorium. Displays depicting each of the six countries served by the church were set up in the building.

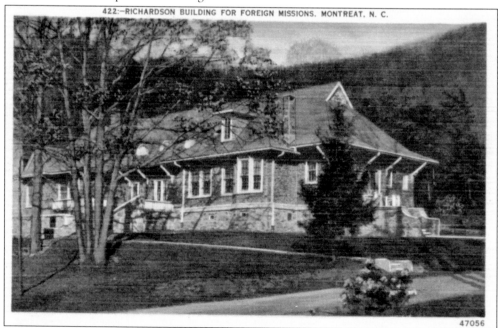

422:—RICHARDSON BUILDING FOR FOREIGN MISSIONS. MONTREAT, N. C.

47056

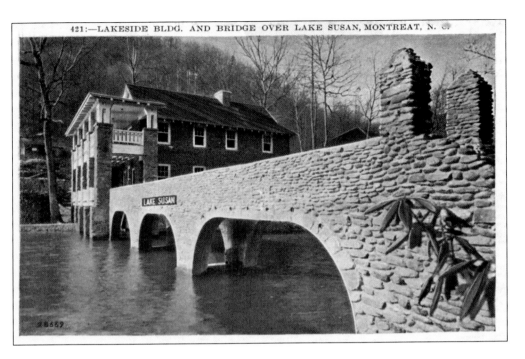

Built in 1925, the Lakeside Building, known to some as the "Left Bank," is perhaps one of the most beautiful structures in Montreat. In the summers, the Committee on Christian Education and Ministerial Relief and the Committee on Home Missions met on the upper floor while the Committee on Religious Education and Publication and the bookstore were on the first floor. One can still imagine the early years when the men of the church sat on its porches discussing pulpit calls and church polity.

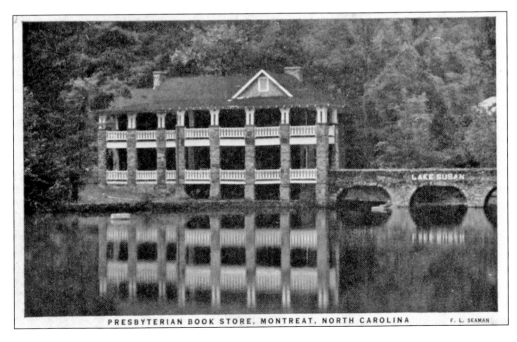

PRESBYTERIAN BOOK STORE, MONTREAT, NORTH CAROLINA F. L. SEAMAN

107

The Christian Education Building was constructed in 1954. It is now called the Kirk Allen Building in honor of its namesake, who was a member of town council and the 1995 acting conference center president. It has served as the meeting place for the Committee on Christian Education, the bookstore, the music store, and is the current site of the town's public meetings.

Coming full circle, the Montreat Bookstore is now housed on the second floor of the Herman Moore Center, constructed in the 1960s on the site of the original frame bookstore. Construction funds were partially donated by the family of Rev. James Howerton, who orchestrated the 1906 Presbyterian purchase of Montreat. The top floor is occupied by Ten Thousand Villages, and the general store occupies the ground level.

46645

Gaither Hall stands as testimony to Sadie Gaither Anderson, Montreat's most generous donor for more than 50 years. Built in 1935, Sadie Anderson donated $60,000 for the structure's construction. It is named in honor of her parents. She was an only child, and she and her husband, Robert, had no children. Inheriting a fortune from her parents, Sadie donated to many Montreat building projects, supported the college operations, and provided scholarships. She died in 1962 at age 90. The value of her estate as reported by the *Asheville Citizen* was $920,320.02, and funds from the Anderson Foundation established by her estate are still being distributed. Gaither Hall continues to be the center of the Montreat College campus. When built, the hall housed a science laboratory, 13 classrooms, a library, and a chapel seating 600. The Montreat Presbyterian Church moved its worship services to the chapel in 1936. Ruth and Billy Graham were married there on August 13, 1943. When Ruth Bell Graham died in June 2007, she held the distinction of being its longest continuous member, joining in 1941.

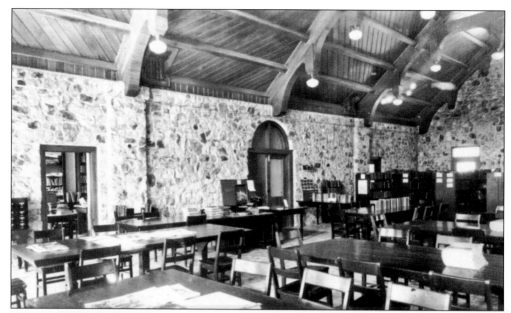

The core of the Gaither Library was formed by the 1,300-volume lending library started in 1898 by Cora A. Stone, who had contracted tuberculosis while a missionary to Japan. Virginia Buchanan was librarian at Montreat College from 1951 to 1972. She remembers that the lighting in the beautiful stone library in Gaither Hall was always dim, prompting a visiting accreditation committee to report, "The lighting is suitable for subdued entertaining" rather than study. (PHC.)

The L. Nelson Bell Library was built in 1972 on the site of the William Henry Belk home. Dr. Bell, for whom the library was named, was a surgeon, author, moderator of the General Assembly, and missionary to China. Ruth Bell Graham was his daughter.

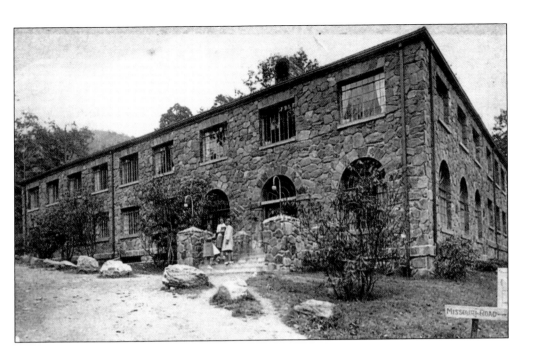

College Hall (above), now McGregor Hall, was built in 1941 when there were 81 high school and 221 college students. Accommodating 106, it was the first housing built primarily for student use. In 1959, the high school program was dropped, and it became Montreat-Anderson Junior College, a coeducational institution. Davis Hall (below), the men's dorm, was built in 1964. In 1986, the institution offered an accredited four-year program, and on August 22, 1995, it retook the name Montreat College.

The Ben Long fresco *Return of the Prodigal* is the focal point of the Chapel of the Prodigal on the Montreat College campus. It was dedicated on October 18, 1998, with the words "Strength and beauty are in His Sanctuary," from Psalm 96:6.

On December 30, 1912, Dr. Robert Anderson and William H. Belk purchased the 28-acre hunting preserve and lodge previously owned by John Huyler. In 1925, they opened Camp Montreat for Girls on the property off Lookout Road (the present site of the college ball field). (BH.)

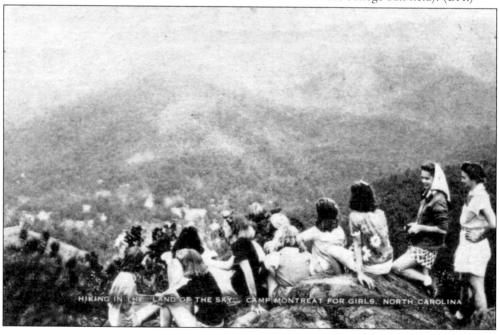

HIKING IN THE "LAND OF THE SKY" CAMP MONTREAT FOR GIRLS, NORTH CAROLINA

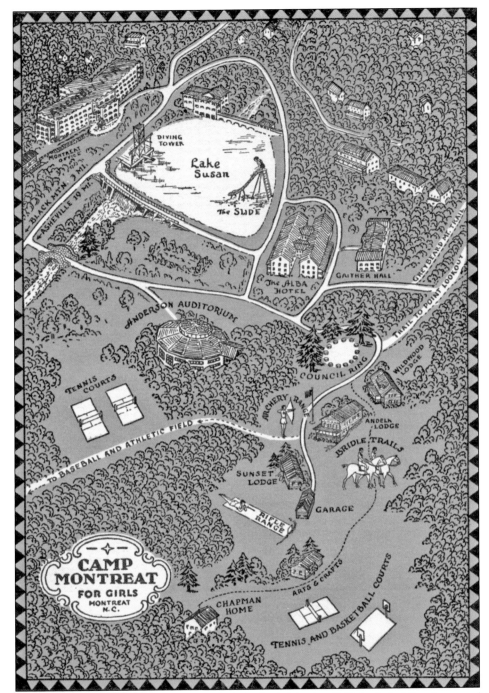

This map shows the Camp Montreat of 1941. Activities in 1941 included Sunday worship at Anderson Auditorium, horseback riding, archery, and swimming in Lake Susan. Campers were divided into Native American tribes with friendly, but fierce, competition among them. Dr. Frank Richardson of Black Mountain was the camp physician. Alice Anderson "Macky" McBride of French Camp, Mississippi, was the much-loved director from 1933 to 1950. The camp ran through 1967.

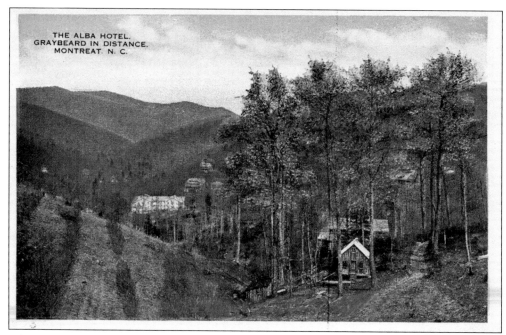

THE ALBA HOTEL.
GRAYBEARD IN DISTANCE.
MONTREAT. N. C.

John Huyler's hunting lodge, renamed "Andelk" by Anderson and Belk, was the first camp building. There was little interaction between the campers and other Montreat youth during the summer season. However, to the consternation of the night watchman, "G-man" Whitaker, and the campers, the "Wilde boys" (Henry, Bill, and Carlton), who came to Montreat each summer, were known to toss apples from the orchard onto the roofs of the camp lodges.

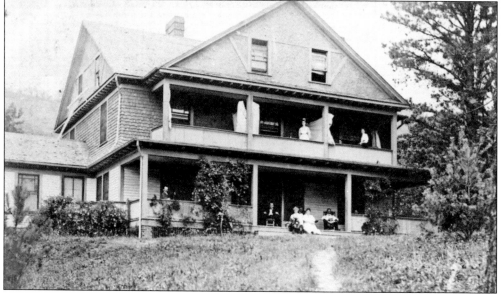

Dr. Clyde E. Cotton built his sanatorium just outside Montreat before 1905. In the 1930s, Alice Anderson "Macky" McBride ran Camp Bridewood for young boys and girls at the former sanatorium, while also directing Camp Montreat. After leaving Camp Montreat, she opened Camp Merri-Mac in the former sanatorium. Her loyal Montreat campers followed. Many of them have now returned to live in the area permanently.

Seven

COMMUNITY LIFE

Presbyterians are part of a "connectional" church. Each congregation is connected to all others through its organizational structure. Many in Montreat are connected by family, with fifth and sixth generations coming to Montreat. Others are connected by professional ties, having served as ministers and missionaries. Some are bound by school ties, having attended the same Presbyterian colleges and seminaries. Others are connected by their attendance at conferences or their service as summer staff. All in the community are connected by their love of Montreat. Early Montreaters often came and stayed for the summer to escape the heat and mosquitoes of the lowcountry. Bible lessons on the front porch, hikes to Mount Mitchell, swimming in Lake Susan, and ball games were highlights of the summer. The conference center planned activities for the youth. Adults enjoyed visiting, sharing meals, and playing parlor games, but bridge was strictly forbidden. Though some things have changed, many community activities remain the same. The conference center still provides a summer club day camp for the children, and hikers enjoy the 30 miles of trails in the Wilderness Conservancy, but swimmers now use the pool rather than the lake, and bridge is a very popular pastime. Since the 1960s, the entire community has gathered for a July Fourth parade around Lake Susan, and Friday evening square dances at the Barn, with Glenn Bannerman and the Stoney Creek Boys band, have become a treasured summer tradition.

The Community Building was the first public structure erected in Montreat. Built *c.* 1900 for $1870.12, it housed the first school and church. The Montreat Presbyterian Church was founded here in 1906 with 25 members. Twenty-one of the founding members were female, of which 15 were single. The building is the current site of the Montreat Post Office. (Postcard by Jane Frist.)

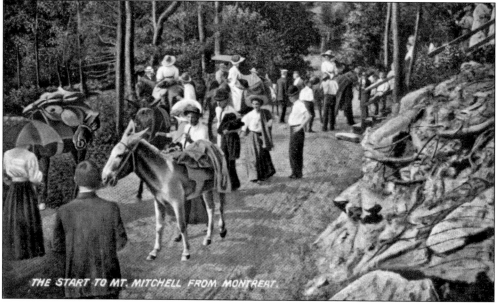

THE START TO MT. MITCHELL FROM MONTREAT.

This card was made in Germany and published in 1909 by the Presbyterian Committee of Publication (PCUS). As shown, 15-mile excursions to Mount Mitchell have long been a favorite adventure. Today a group of mostly "over sixties" make an annual "Ageless Wonders" hike to Mount Mitchell from Montreat. (RN.)

Postal service in Montreat began on January 2, 1899. In 1907, the first post office building was constructed along Flat Creek, directly across from the Community Building. Commercial development soon followed with the addition of a grocery store, drugstore, beauty shop, filling station, and a telephone exchange. This commercial center was torn down in the 1960s.

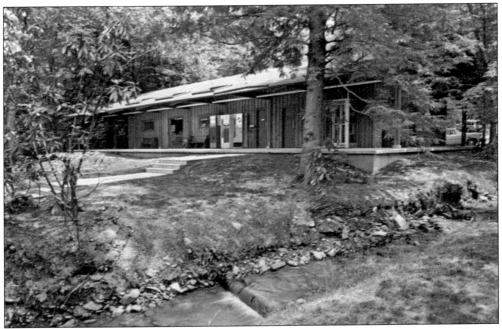

The second commercial center was built in the 1960s, housing the post office, a general store, Laundromat, and filling station. A telephone booth at the rear provided a convenient way to call home. The general store is now located in the Moore Center.

As seen in this image from the 1950s, winter brings a special beauty. It can also bring tragedy. In 1927, a 14-year-old Montreat resident, Carl Williams, fell through the ice and drowned in Lake Susan. His brother Donald Eugene Williams, then only 13, witnessed the tragedy. Don and his wife, Laura, became missionaries to Brazil in 1946, serving for 37 years. Don Williams was born in Montreat on June 8, 1915, and was the first son of the Montreat Presbyterian Church to enter the mission field.

Summer visitors and residents enjoy quiet times in the gazebo on the banks of Lake Susan. During the Worship and Music Conference, musicians gather here to play their instruments, sending melodies throughout the valley.

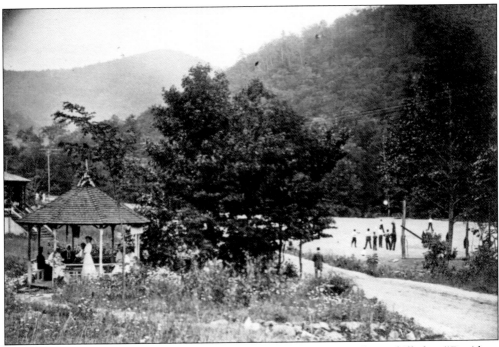

Baseball was a popular pastime with one of the most storied games being billed as "Davidson against the world." Those not watching the game could enjoy the gazebo and water-driven whirly-gigs at the house across the street, which has a spring running underneath the structure (231 Assembly Drive). (PHC.)

LOVER'S ROCK, MONTREAT, N. C.

Montreat has always been a special place for romance with many meeting and marrying here. This card of Lover's Rock and the bridge was published before 1906, and while the location is somewhat uncertain, it is thought to be along Greybeard Stream just above the lake.

MOUNTAIN STREAM WHICH SUPPLIES LAKE AT MONTREAT, N. C.

Many enjoy the solitude and quiet beauty of the streams and the forests. For generations, children have enjoyed "rock hopping" in creeks. Residents along North Carolina Terrace have frequented Wynne-Lithia Springs.

M-7 WYNNE LITHIA SPRING, ON NORTH CAROLINA TERRACE, MONTREAT, N. C.

E-8877

The Men's Club, now the Barn, was built in 1919 at the top of Lake Susan. It featured magazines, a pool table, and a bowling alley and was deemed "quite a center for the amusement and recreation of the men." The Boy's Club, now the Currie Craft Center, was built in 1925 just behind the Lakeside Building. The Girl's Club was built in 1916. Now called the "Velvet Moose," it is used by the summer club program and the collegiate staff. Today's youth also enjoy summer programs at the Bill Wilde Youth Center in Robert Lake Park. The center was established in 1980 in the remodeled Montreat garage and maintenance shop. (Below, postcard by Merri Alexander Bass.)

MEN'S CLUB BUILDING, MONTREAT, N. C.

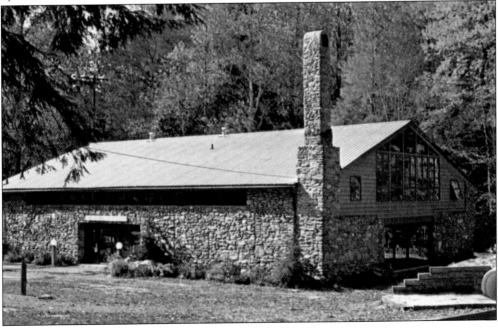

121

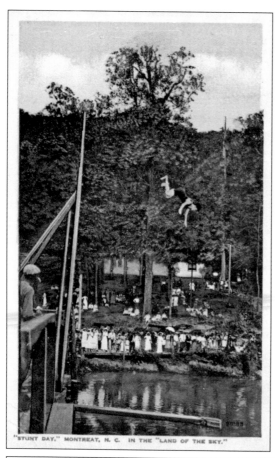

"STUNT DAY," MONTREAT, N. C. IN THE "LAND OF THE SKY."

By 1912, Stunt Day was a popular event in Montreat with crowds gathering on the lakeshore and wooden dam to watch. Proper bathing attire was a serious issue. In 1924, the Woman's Club was tasked with ensuring that swimmers wore appropriately modest swimsuits and that the swimmers were never to wear all-white bathing suits. (Below, BH.)

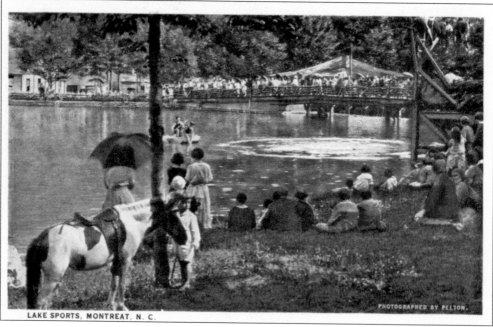

LAKE SPORTS, MONTREAT, N. C.

PHOTOGRAPHED BY PELTON.

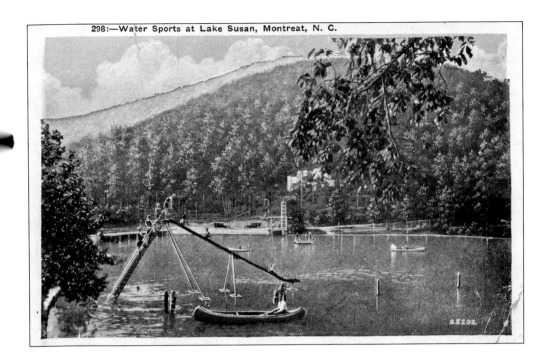

298:—Water Sports at Lake Susan, Montreat, N. C.

For more than five decades, Lake Susan was a water playground boasting a high diving tower, sliding board, and swimming beach. Volleyball by the lake and golfing were also popular. There was a five-hole golf course located between the lake and the gate. Until the 1950s, a miniature golf course was located near Assembly Inn. The small stone clubhouse still stands on the grounds just below William Black Lodge.

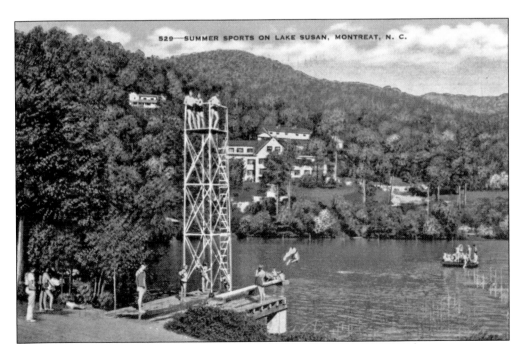

529—SUMMER SPORTS ON LAKE SUSAN, MONTREAT, N. C.

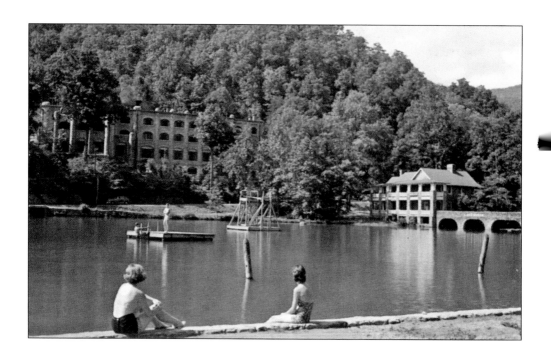

In the 1950s and 1960s, a floating dock was anchored in Lake Susan. The words on the side of the dock, appropriate for this bastion of Presbyterians, were "Please Do Not Walk on the Water." The swimming pool was built when officials declared that swimming in Lake Susan was unhealthy. Those who swam in Lake Susan declared in amazement, "No germ could possibly live in Lake Susan. It was too cold!" (Below, postcard by Merri Alexander Bass.)

While there is no longer swimming in Lake Susan, new memories are still being made there. Young and old alike fish for trout. At the end of each Youth Conference, a thousand high school students ring Lake Susan with lighted candles illuminating the dark. Since 1990, a pair of swans has graced the lake, their movements framed by the stone buildings of Montreat and the Seven Sisters and Blue Ridge Mountains.

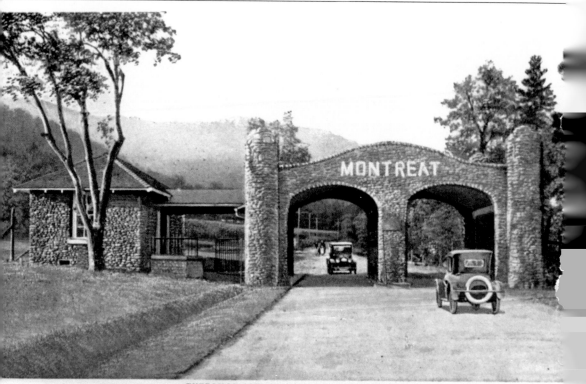

ENTRANCE GATE TO MONTREAT GROUNDS

It is now time to leave. Many commemorate their stay with a photograph by the gate, and for almost a century, artists have captured its beauty in oils and watercolors. We hope you have enjoyed your postcard journey to Montreat and, as written in the 1930s, "Come to Montreat, see its beauties, enjoy its privileges, and you will come again." We look forward to seeing you. Sincerely, Mary and Joe.

BIBLIOGRAPHY

Anderson, Robert Campbell. *The Story of Montreat from Its Beginning, 1897–1947.* Kingsport, TN: Kingsport Press, 1949.

Davis, Calvin Grier. Montreat, *A Retreat for Renewal, 1947–1972.* Kingsport, TN: Arcata Graphics/Kingsport, 1986.

Lovelace, Jeff. *Mount Mitchell: Its Railroad and Toll Road.* Johnson City, TN: The Overmountain Press, 1994.

Maxwell, Elizabeth. *A Flowing Stream: An Informal History of Montreat.* Alexander, NC: WorldComm, 1997.

Neville, Susan. *Cottage Owners: Montreat Directory.* Montreat, NC: self-published, 2006.

Schwarzkopf, S. Kent. *A History of Mount Mitchell and the Black Mountains: Exploration, Development, and Preservation.* Raleigh, NC: North Carolina Division of Archives and History, 1985.

Smylie, James H., editor. "Montreat Conference Center." Special issue commemorating the centennial of the Montreat Conference Center. *American Presbyterians: Journal of Presbyterian History,* Vol. 74 No. 2. Philadelphia, PA: Presbyterian Historical Society, 1996.

Spence Jr., Thomas Hugh. *The Historical Foundation and Its Treasures.* Montreat, NC: Historical Foundation Publications, 1956.

Vaughn, Catherine Stewart. *Messages of Reconciliation and Hope.* Franklin, TN: Providence House Publishers, 1997.

Vaughn, Emilie Miller. *Mother Pioneered in Montreat (Her Letters 1898–1899).* Ithaca, NY: self-published, 1972.

Wilkinson, Henrietta, and Bluford Hestir. *The First Chapter: Early Montreat Homes 1897–1917.* Montreat, NC: Heritage Homes Committee, 1997.

Wright, Perrin. *Geographic Place Names in and around Montreat, NC.* Montreat, NC: self-published, 2003.

DISCOVER THOUSANDS OF LOCAL HISTORY BOOKS
FEATURING MILLIONS OF VINTAGE IMAGES

Arcadia Publishing, the leading local history publisher in the United States, is committed to making history accessible and meaningful through publishing books that celebrate and preserve the heritage of America's people and places.

Find more books like this at
www.arcadiapublishing.com

Search for your hometown history, your old stomping grounds, and even your favorite sports team.

Consistent with our mission to preserve history on a local level, this book was printed in South Carolina on American-made paper and manufactured entirely in the United States. Products carrying the accredited Forest Stewardship Council (FSC) label are printed on 100 percent FSC-certified paper.